·Wildlife·
The
Artist's View

·Wildlife·
The Artist's View

An exhibition organized by
Leigh Yawkey Woodson Art Museum
Wausau, Wisconsin

Exhibition Tour

Leigh Yawkey Woodson Art Museum
Wausau, Wisconsin
April 7 - June 10, 1990

Rochester Museum & Science Center
Rochester, New York
July 12 - August 26, 1990

Krasl Art Center
St. Joseph, Michigan
September 15 - October 31, 1990

The R. W. Norton Art Gallery
Shreveport, Louisiana
January 19 - March 2, 1991

The Cleveland Museum of Natural History
Cleveland, Ohio
March 23 - May 4, 1991

Grassmere Wildlife Park
Nashville, Tennessee
May 25 - July 7, 1991

The High Desert Museum
Bend, Oregon
July 27 - September 17, 1991

Notes

© 1990, Leigh Yawkey Woodson Art Museum

Library of Congress
Cataloging-in-Publication Data
Wildlife: the artist's view: an international
exhibition organized by Leigh Yawkey Woodson
Art Museum, Wausau, Wisconsin.
 p. cm.
Catalogue to accompany the exhibition shown
from April 7, 1990 to September 17, 1991 at
various museums.
ISBN 0-945529-03-1
1. Wildlife art – Exhibitions. 2. Art, Modern –
20th century – Exhibitions. I. Leigh Yawkey
Woodson Art Museum.
N7660.W46 1990 90-5652
704.9'432'0904807473–dc20 CIP

The exhibitions and programs of the Leigh Yawkey Woodson
Art Museum are supported in part by a grant from the
Wisconsin Arts Board with funds from the State of Wisconsin
and the National Endowment for the Arts. The Museum has
also received general operating funds for fiscal year 1989-90
from the Institute of Museum Services, a Federal agency.

Accredited by the
American Association of Museums

Contents

Foreword

I am a relative newcomer to the field of wildlife art. In fact, the broad concept of "wildlife" is essentially new to me. Growing up in an East Coast urban environment, my exposure to nature and its inhabitants was limited to summers in the mountains and periodic visits to the city zoo. This has been changing with my gradual migration westward, and, without question, the most noteworthy changes have occurred since I assumed the directorship of the Leigh Yawkey Woodson Art Museum in September 1987.

In spring 1987 I was fortunate to experience firsthand the Museum's *Wildlife in Art* exhibition – my initial introduction to the concept of animals as subject for the artist. The range of styles, handling, points of view and artistic sensitivities all impressed me. There was quality work to consider and, in addition, many artists had important things to say about environmental concerns and species protection.

Wildlife in Art was a significant departure for the Leigh Yawkey Woodson Art Museum, which had focused its annual "flagship" exhibition on birds since the Museum opened in 1976. This broadening of subject matter to encompass the entire animal kingdom was successful beyond expectations. The response to the exhibition's Wausau premiere and subsequent ten-city tour led to the decision to organize a similar exhibition on a triennial basis.

With *Birds in Art* a virtual "household name" to scores of artists, birders, sportsmen, environmentalists and nature art aficionados worldwide, it was essential that the Museum's more broadly focused animal exhibition be given an identity of its own. Countless staff sessions, Board committee meetings and discussions with artists gave rise to *Wildlife: The Artist's View*. Our intent was to signal a basically unlimited range of acceptable subject matter – the entire spectrum of the wild kingdom – but, more significantly, to put the burden of responsibility on the artist to interpret and present the subject for the viewer – the artist's point of view.

This direction and new focus hit a responsive chord: inquiries, interest, response and enthusiasm for *Wildlife: The Artist's View* have been substantial. An open-juried format yielded entries from close to four hundred artists. A multi-talented jury was convened at the Museum to review the submissions: Sarah Boehme, curator of the Whitney Gallery of Western Art of the Buffalo Bill Historical Center in Cody, Wyoming, contributed her expertise as an art historian with an emphasis on the art of the West; John Buchanan, director of The Dixon Gallery and Gardens in Memphis, Tennessee, brought his considerable experience with exhibitions and interest in flora and fauna; and Ralph Palmer, internationally recognized zoologist, author and illustrator from Tenants Harbor, Maine, rounded out the team. Their collective wisdom and sound judgments produced an outstanding exhibition.

Wildlife: The Artist's View brings together a remarkable assortment of artistic styles, interpretations, subject matter and talent. Many well-established, familiar artists are included side by side first-time exhibitors. Similarly, views of Arctic animals share the spotlight with desert critters. Whales, reptiles and birds provide both a complement and a contrast to depictions of African elephants, giraffes, lions and hippopotamuses – the classic images the word "wildlife" brings to mind. In short, the exhibition is a veritable menagerie encompassing the animal world's A to Z – alligator to zebra!

In conjunction with the exhibition, the Leigh Yawkey Woodson Art Museum honors an acknowledged master. Bob Kuhn, our Distinguished Wildlife Artist, is without equal in his lifelong preoccupation with the animal kingdom and, more important, his successful quest to capture the very essence of his wide-ranging subjects. Regarded as a mentor and inspiration to countless artists, Bob Kuhn's signature style is renowned far and wide. His true concern for his subjects and his staunch belief in his stylistic approach have made him a preacher of sorts for the significance of wildlife art. Throughout the preparations for *Wildlife: The Artist's View*, he has been cooperative and good-spirited; our sincere appreciation and hearty praise are extended to Bob Kuhn.

The national tour of *Wildlife: The Artist's View* considerably extends the exhibition's reach. Through 1990 and into 1991, approximately sixty two- and three-dimensional works will travel almost coast to coast. Audiences in Rochester (New York), St. Joseph (Michigan), Shreveport (Louisiana), Cleveland (Ohio), Nashville (Tennessee), and Bend (Oregon) will experience the best of contemporary

wildlife art at the Rochester Museum and Science Center, Krasl Art Center, The R. W. Norton Art Gallery, The Cleveland Museum of Natural History, Grassmere Wildlife Park, and The High Desert Museum respectively. To the staffs of these institutions, we extend our thanks for their cooperation and decision to be part of this exciting undertaking to increase the awareness and appreciation of wildlife art.

An exhibition of this magnitude requires funding from many sources and the cooperation and support of many individuals. The Aytchmonde P. Woodson Foundation and the Museum's founding families – John and Alice (Woodson) Forester, Lyman and Nancy (Woodson) Spire, and the family of the late Margaret Woodson Fisher – continue to ensure the successful operation of the Museum through their leadership and ongoing generosity. The Board of Directors has provided guidance throughout this project, and the Museum's Friends and corporate contributors have demonstrated their support in record numbers. Special funding for *Wildlife: The Artist's View* has been received from the Gannett Foundation for public relations efforts and the Clyde F. Schlueter Foundation for complementary public programming. In addition, for fiscal year 1989-90 the Museum has received significant funding from the Wisconsin Arts Board and the Institute of Museum Services.

A wide variety of talents and expertise is also essential for a project such as this one. The outstanding staff of the Leigh Yawkey Woodson Art Museum ably and enthusiastically play many roles: Marcia Theel oversees public relations and countless administrative details; Andy McGivern and Jane Weinke tend to the mechanics of photography, crating, shipping and installation; Donna Sanders and Shari Schroeder compile and coordinate the catalogue material and all-important artist data and, with the assistance of Arline Stark and Katy Rogalla, tend to many other details; Cynthia Young and Lisa Walk Martin use their creative talents in developing related programming and instructing the Museum's dedicated docent corps; and Georgia Lang extends the Museum's hospitality in conjunction with the Receptions Committee as coordinator of the opening weekend festivities. They are all deserving of heartfelt thanks.

Two special features of *Wildlife: The Artist's View* are the fully illustrated exhibition catalogue and the related activities. This publication, which serves as the permanent document of the project, presents the artists and their work in a readable and coherent format. The book's flexible design is the work of Creative Services and the masterful printing was done by Marathon Press, both part of Marathon Communications Group of Wausau. The programs planned to complement the exhibition and to help the works of art "come alive," especially for young people, demonstrate a new approach for the Museum. Ranging from an Art Safari – with make-your-own binoculars – to a session with a wildlife photographer and from an Earth Day musical debut – Peter Strickholm's *Canyon Suite* for flute – to gallery "picnics" for little visitors and their grown-up friends, the diversity of events is sure to educate and delight our audiences.

While the disparate parts of the project come together over time, were it not for the artists themselves and the generous lenders of their works, *Wildlife: The Artist's View* would not be a reality. The eighty-one artists, whose creative expressions and enlightened interpretations of the world's wildlife grace these pages and our gallery walls, deserve our deepest appreciation and gratitude. Thanks, too, are due the many individual and gallery lenders for sharing the artworks with us.

I have come a long way in three short years; I am no longer a stranger to wildlife art. I have come to recognize and appreciate the aesthetic goals and artistic qualities of this specialized genre of art. My experiences have been intensified by exciting learning opportunities such as *Wildlife: The Artist's View*. The artworks have taught me about the natural world while at the same time heightening my sensitivities to the many pressing global environmental concerns. If others can be affected similarly – to enjoy the beauty of the works themselves or to learn about the subjects depicted – the goals of *Wildlife: The Artist's View* will have been met.

Kathy Kelsey Foley
Director
Leigh Yawkey Woodson Art Museum

Distinguished Wildlife Artist

Bob Kuhn

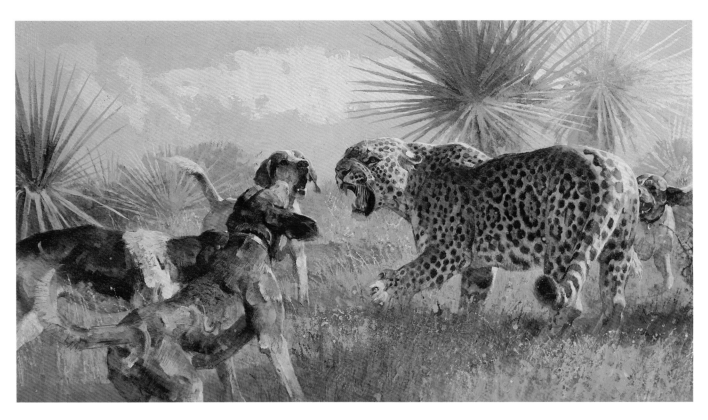

Bob Kuhn is about the top of the heap as far as wildlife or any subject for that matter. His paintings look fresh and loose like they required no effort at all. His colors always go a step beyond to capture the feeling.[*]

For fellow artists, critics and wildlife art enthusiasts, Bob Kuhn is simply without peer. His work represents the best of wildlife art and has been described as having the ability to take its viewers into the very midst of nature's secret places, almost into the minds of the animals themselves.

Kuhn has devoted over fifty years to art, more if you count his childhood devotion to drawing. Born on January 28, 1920, in Buffalo, New York, some of Bob Kuhn's earliest memories are of visits to the Buffalo Zoo. He cannot remember a time when he was not fascinated by animals.

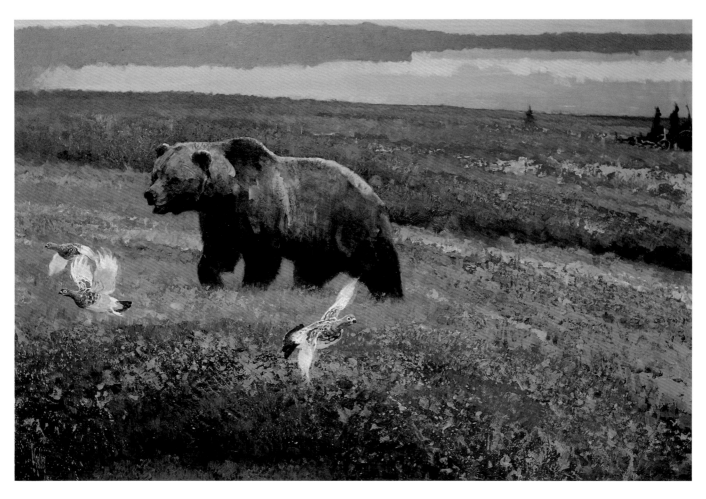

Across the Barrens, 1985
Grizzly bear and
willow ptarmigan
Acrylic on board
22 x 32

Courtesy of
Settlers West Galleries,
Tucson, Arizona

"There's no real answer to why I paint animals," Kuhn has said. "All I know is that when I was a very little boy, there was something about animals that grabbed hold of me and it translated itself into my need to scribble drawings of them with chalk or crayons or whatever came to hand. I've been doing it ever since."

Despite his compulsive interest in animals, he never wanted to study them from the scientific point of view. By the time he was in high school, there was no doubt in his mind that he would be an artist. Upon graduating from a three-year course in illustration at the Pratt Institute in Brooklyn in 1940, Kuhn became a free-lance illustrator.

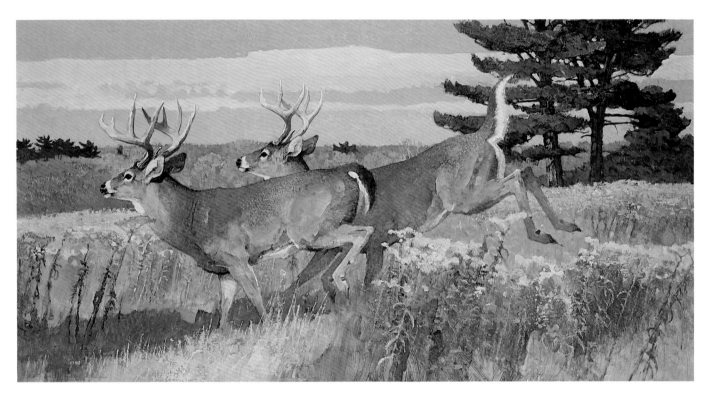

Except for a brief stint in the Merchant Marine in World War II, Kuhn's artwork has always supported him and his family. Even while in the Merchant Marine, he accepted free-lance assignments and did the original illustrations for Jim Kjelgaard's *Big Red* aboard ship.

By age 25 he had already done several covers for *Outdoor Life*. As a successful illustrator, he had all the work he could handle. Then in the early 1950s he switched to *Field & Stream*. Working at *Field & Stream* offered an opportunity to get to know staff members that resulted in trips to Alaska and Africa in 1956. In the early 1960s he returned to *Outdoor Life* until 1970, when he made the decision to devote his full-time attention to animal art.

October Prime, 1989
White-tailed deer
Acrylic on board
22 x 40

Collection of Larry Huffman

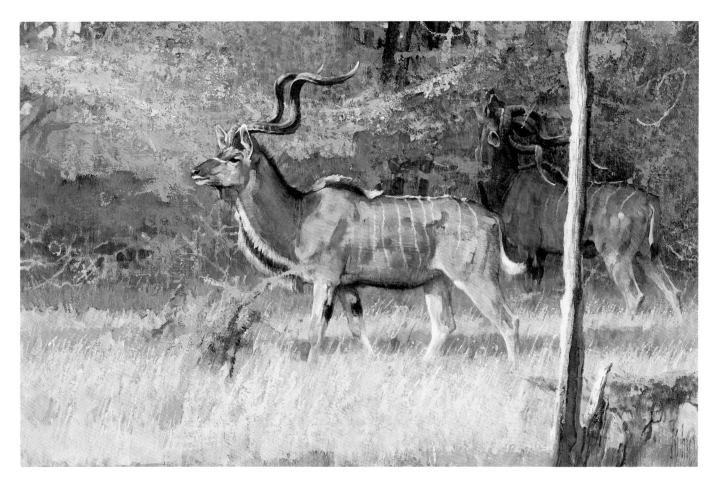

Numero Uno, 1989
Greater kudu
Acrylic on board
24 x 36

Courtesy of
Sportsman's Edge/King Gallery,
New York City

That first of ten visits to Africa provided inspiration for future work. Unspoiled Africa was a wildlife artist's dream. Kuhn made paintings there that were not preliminaries for an art director's assignment; when he returned home, he started "easel paintings." While illustrating continued to pay the bills, Kuhn devoted more and more time to painting and the results were displayed in several New York City galleries. Although Kuhn's early reputation was largely built on African subjects, he is equally at home with North American themes.

Over the years Kuhn has seen his work develop from traditional, realistic portrayals to increasingly impressionistic and painterly studies. He elaborated on his style in the recently published monograph *The Art of Bob Kuhn* by Tom Davis.

"The abstract relationship should be a concern of every artist. If it's not, he's destined to make lousy paintings. A good painting has to have a solid concept. It has to have some judgment applied to it, and it has to have some objective, whether it is an abstraction or not. I think a good realistic painting is also a good abstract painting. It has to have a framework, a structure that would hold up whether there were any facts or details in it or not. Good representational painters, Rembrandt or anyone else, always have a strong design aspect in their work. Some artists – Rothko, for example – use very simple, basic shapes; the excitement comes in the treatment of the surface vibrations and the color, that's all there is. But it is exciting.

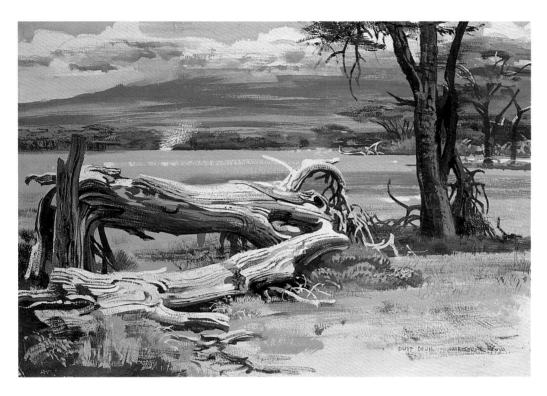

Amboseli Reserve, Kenya, c. 1963
Gouache on illustration board
10 x 14

Collection of the artist

"You can be totally faithful to nature, but you do so at the sacrifice of any potential for art.... Every area does not need to be busy, but it has to make some sense in the overall design.... If the painter isn't prepared to assert himself and control the elements in a painting, he's not functioning as an artist.

"The older I get, the more I strive for less detail and more mass. I try to express the truth without necessarily putting down everything that I see or know."

*Chuck Kneib, an artist represented in *Wildlife: The Artist's View*, wrote these lines about Bob Kuhn in response to a question about artistic influences.

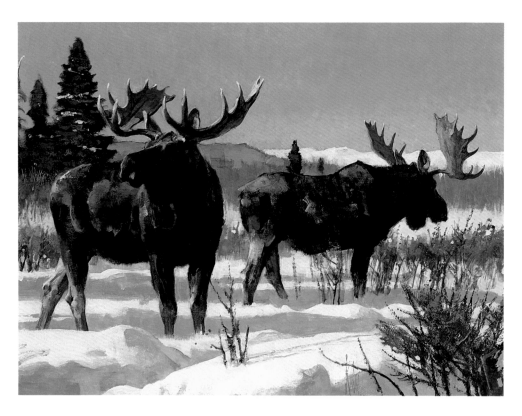

Bob Kuhn

b. 1920, United States

RESIDES: Roxbury, Connecticut
EDUCATION: Pratt Institute, Brooklyn, New York
MAJOR FIELDS: Illustration
EXHIBITIONS: *Wildlife in Art*, 1987; *Miniatures '89*, White Oak Gallery, Edina, Minnesota
COLLECTIONS: Gallery of Sporting Art, Genesee Country Museum, Mumford, New York; Museum of Natural History, Las Vegas, Nevada; National Cowboy Hall of Fame and Western Heritage Center, Oklahoma City; Wildlife of the American West Art Museum, Jackson, Wyoming

BIBLIOGRAPHY: "The Art of Bob Kuhn: A Message From a Master," *Wildlife Art News*, January/February 1988; *The Art of Bob Kuhn*, Briar Patch Press, 1989; "Art & Etc.," *Sporting Classics*, March./April 1990
REPRESENTATIVES: Collector's Covey, Dallas, Texas; The Drummond Gallery, Coeur d'Alene, Idaho; Sportsman's Edge/King Gallery, New York City; Settlers West Galleries, Tucson, Arizona

Sunny Morning, 1985
Moose
Acrylic on board
14½ x 18½

Collection of
Wildlife of the
American West Art Museum
(The JKM Collection),
Jackson, Wyoming

Throughout the catalogue, titles are given in italics with the date of the work following. If not included in the actual title, the common animal name is generally provided on the next line. Dimensions are given in inches with height preceding width for two-dimensional works and height preceding width preceding depth for three-dimensional objects.

The information on the artist and the work has been compiled and selected from materials provided by the artists, lenders and representatives as well as from published articles and books relevant to wildlife art and artists. Quoted material was supplied by the artists unless the quote is followed by an asterisk (*) which indicates a direct quotation from a source cited.

The biographical listings also rely on information from the above sources. The material has been edited to reflect recent achievements, generally 1988 through the present. Reference to an artist's inclusion in the Leigh Yawkey Woodson Art Museum's 1987 exhibition *Wildlife in Art* has been included under "exhibitions." An artist's participation in the Museum's *Birds in Art* exhibition is only cited for the years 1987, 1988, 1989. The *Birds in Art* catalogues can be consulted for further information.

Titles of exhibitions are usually given for all but one-person exhibitions when only the gallery/museum name, date and location are listed. If an artist is represented in an exhibition more than one year, the reference is given only once followed by the dates of participation (eg. *Artists of America*, 1988-89, Colorado History Museum, Denver). If an annual exhibition does not have a proper name but instead its title is the same as the organizer (eg. *National Academy of Design*), the organization only is given in italics preceded by the appropriate date. With regard to an award received in conjunction with an exhibition, the reference is cited only under "awards" but also signifies an artist's participation in the exhibition.

Publications refer to articles or books authored or illustrated by the artist. Bibliography includes a variety of sources written about the artist.

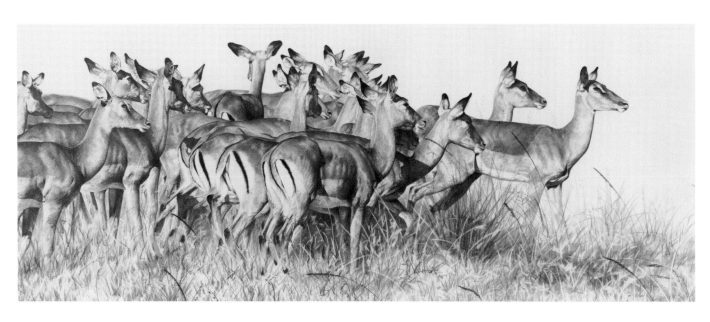

J. L. Adams
b. 1954, United States

Who's Going First?, 1989
Impala
Graphite on illustration board
11 x 27

Collection of the artist

"In Kenya I saw many loosely grouped impalas, but only once did I come across a tightly bunched gathering. I'll never know why forty to fifty females were together like this – there was no sign of a head male or any predator – but awe and joy mingled as I observed the multi-bodied mass poised as one unit. The warm, dry air of the Mara seemed to hum with their tension. The beauty of the moment, with the sun shining off the impalas' coats and the wind playing in the grasses, will always stay with me. *Who's Going First?* was completed shortly after I returned home. I love form and light almost more than color so incorporating these elements into a composition in pencil is perfect for me. The absence of color does not distract from the forms and their interaction with light."

RESIDES: Boyne City, Michigan
EDUCATION: Lake Superior State College, Sault Ste. Marie, Michigan
MAJOR FIELDS: Wildlife ecology and management
EXHIBITIONS: National Wildlife Federation, 1988, Vienna, Virginia; Virginia McCune Art Center, 1988, Petosky, Michigan; Coyote Woman Gallery, 1989, Harbor Springs, Michigan
REPRESENTATIVES: Coyote Woman Gallery, Harbor Springs, Michigan

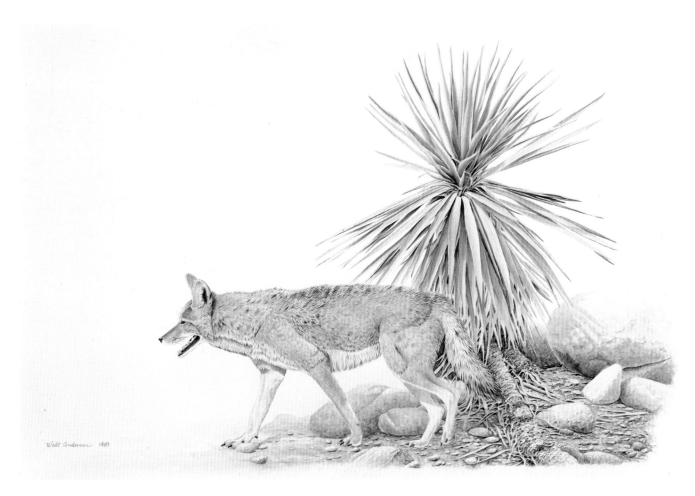

"My paintings stem from a passionate, perhaps obsessive, love for the natural world. A naturalist and a wildlife artist have similar goals – to explore nature's diversity and somehow extract the significant, the essential character of an organism or ecosystem. The challenge is to choose from among a multitude of interpretive options, then express the option as fluently as possible, regardless of the medium. In *Coyote and Yucca,* the yucca, rocks and bare ground imply a harsh, challenging environment, whereas the coyote projects pure confidence, a mastery of that environment which cannot diminish its life force."

RESIDES: Eugene, Oregon
EDUCATION: Washington State University, Pullman; University of Arizona, Tucson; University of Michigan, Ann Arbor
MAJOR FIELDS: Wildlife biology and resource ecology
EXHIBITIONS: *Pacific Rim Wildlife Art Show,* 1988-89, Tacoma, Washington; *Our Southwest,* 1989, National Audubon Society, Tucson
COMMISSIONS: Santa Rita Lodge, Sahuarita, Arizona
BIBLIOGRAPHY: "Walt Anderson's Wildlife," *Animals,* July/August 1988

Walt Anderson
b. 1946, United States

Coyote and Yucca, 1989
Watercolor on board
15½ x 24

Collection of the artist

Tony Angell
b. 1940, United States

Indomitable, 1988
Northern harrier
Carrara marble
6 x 15½ x 12½

Collection of
Dr. and Mrs. Raymond Marty

When Tony Angell began to work with the Carrara marble that was to eventually reveal the injured form of a northern harrier, he was compelled to recognize his own emotions at that time. "To some degree I identified with the fallen bird; my work was an effort to make tangible my state of mind. Ironically, the sculpture became the basis for my recovery instead of an image of resignation. Rather than being downed, the harrier is about to take wing again; hence the title *Indomitable*." In selecting this stone, its horizontal inclination, proportions and color led Angell to "see" that a harrier form lay within.

RESIDES: Seattle, Washington
EDUCATION: University of Washington, Seattle
MAJOR FIELDS: Literature
EXHIBITIONS: *Wildlife in Art*, 1987; *Birds in Art*, 1987; Foster/White Gallery, 1988, Seattle; *Artists of America*, 1988-89, Colorado History Museum, Denver; *National Academy of Western Art*, 1988-89, National Cowboy Hall of Fame and Western Heritage Center, Oklahoma City
COLLECTIONS: Frye Art Museum, Seattle; Leigh Yawkey Woodson Art Museum; Thomas Gilcrease Museum, Tulsa, Oklahoma
PUBLICATIONS: *Marine Birds and Mammals of Puget Sound*, University of Washington Press, 1988 (illustrator and author)
REPRESENTATIVES: Foster/White Gallery, Seattle, Washington; Carson Gallery, Denver, Colorado

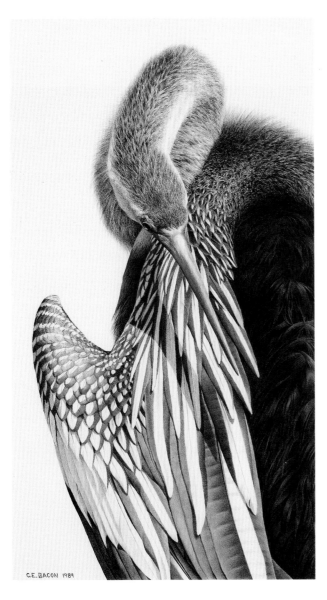

C.E. BACON 1989

Composition and design were the over-whelming concerns as Chris Bacon worked to interpret through watercolor his first personal encounter with an anhinga. "I concentrated on the bird's powerful shapes which belied its gentle demeanor. This dichotomy evoked a sense of awe in me." Bacon's technique allows for the viewer's appreciation of the beauty and sheer presence of the anhinga. His obsession with detail is satisfied by the use of a triple zero brush – with eyelash-sized red sable hairs that form a point as fine as a straight pin – and transparent watercolor, necessitating many successive brush strokes to build up the vivid colors and striking forms.

RESIDES: Burlington, Ontario, Canada
EXHIBITIONS: *Birds in Art,* 1987-89; *Sylvan Real,* 1988, Burlington Cultural Centre, Burlington; *Miniatures '88 and '89,* White Oak Gallery, Edina, Minnesota; *Views of Canada,* 1989, Beckett Gallery, Hamilton, Ontario; *Elephants: The Deciding Decade,* 1989, Zoocheck Canada, Toronto
AWARDS: Artist of the Year, 1989, Ducks Unlimited Canada
BIBLIOGRAPHY: "Chris Bacon, In Search of Excellence," *Art Impressions,* Summer/ May 1989; "Chris Bacon – DU Canada Waterfowl Art Award Winner 1989," *Conservator,* August 1989; "The New Generation: Five Young Wildlife Artists to Keep an Eye On," *U.S. ART,* March 1990
REPRESENTATIVES: Beckett Gallery, Hamilton, Ontario, Canada

Chris Bacon
b. 1960, England

Snake Bird, 1989
Anhinga
Watercolor on rag board
6 x 3⅛

Private collection

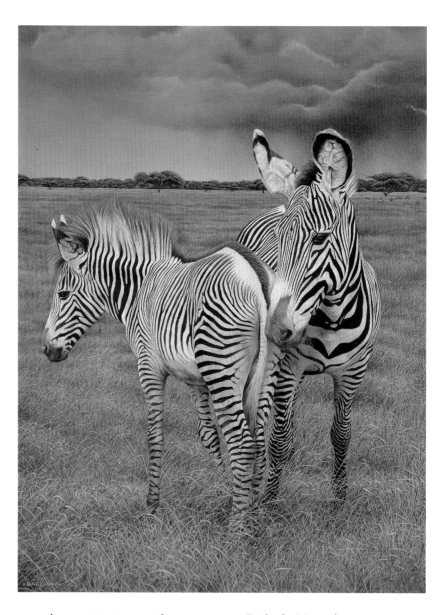

Peter Michael Baedita
b. 1961, United States

Approaching Rains, 1988
Grevy's zebra
Acrylic on canvas
23 x 17

Collection of the artist

"I wanted to portray the sensitive image of a young zebra gently nudged against its mother, while a threatening sky over a vast African plain punctuated the background. The approaching storm signals the end of the dry season and the return of life to the plain. This carefully composed image was designed to show an exciting, convincing and optimistic scene of zebras during a time of environmental rebirth." The success of *Approaching Rains* was dependent upon a landscape bathed in dramatic light, creating an atmosphere of proper color and mood. Peter Baedita finds that an inverse ratio occurs as he paints more with acrylics: He spends less time agonizing over technique and more time devoted to composition, mood and light.

RESIDES: Peabody, Massachusetts
EDUCATION: Massachusetts College of Art, Boston
MAJOR FIELDS: Illustration
EXHIBITIONS: *Tollers and Tattlers*, 1989, Peabody Museum of Salem, Salem, Massachusetts

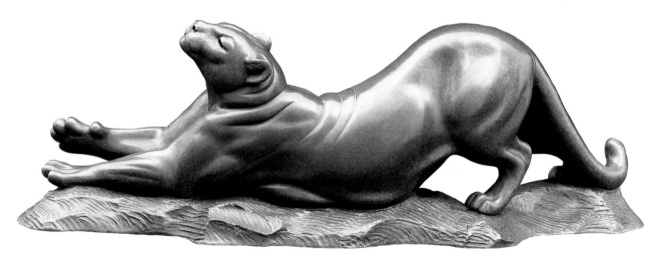

"I started *Cougar Stretch* as a workshop demonstration piece, intending to teach my students about feeling and motion. The inspiration came from watching my two house cats stretch about ten times a day. I found that the first stretch in the morning was the most spectacular. After taking forty to fifty snapshots of that day-starting extension, I was able to get an authentic looking movement for my cougar." Gerald Balciar sees his subject as an independent and contented cat that probably only woke up long enough to lazily move to a spot where the sun will shine on it. This sculpture was done first in clay, next in white Colorado yule marble, and then cast in bronze. "I still like to think of the finished piece as stone. The granite-like patina I applied to the bronze enhances this resemblance."

RESIDES: Arvada, Colorado
EXHIBITIONS: *National Academy of Western Art*, 1989, National Cowboy Hall of Fame and Western Heritage Center, Oklahoma City; *National Art Exhibition of Alaska Wildlife*, 1989, Anchorage Audubon Society, Anchorage; *Miniatures '89*, White Oak Gallery, Edina, Minnesota; *Artists of America*, 1989, Colorado History Museum, Denver
AWARDS: Marguerite Hexter Award, 1989, *Allied Artists of America*, New York City; Chilmark Award, 1989, *National Sculpture Society*, New York City
COLLECTIONS: National Cowboy Hall of Fame and Western Heritage Center
COMMISSIONS: Loyal Order of Moose, Mooseheart, Illinois; Museum of Natural History, Las Vegas, Nevada
BIBLIOGRAPHY: "Bronze: The Rock of Ages II," *Wildlife Art News*, January/February 1988

Gerald Balciar
b. 1942, United States

Cougar Stretch, 1989
Bronze
11 x 28 x 7

Collection of the artist

Robert Bateman
b. 1930, Canada

Midnight, 1988
Gray wolf (black phase)
Acrylic on board
36 x 48

Private collection

Robert Bateman's intent in creating *Midnight* was to show the ominous presence of a mature, lone wolf. He did not seek to convey a sense of threat but rather a mood of seriousness and respect. The rival relationship between wolves and humans is legendary – from the nursery rhyme "big, bad wolf" to the more real and recent erosion of habitat – and fosters mutual mistrust. In actuality, the species have much in common: both are gregarious, have a hierarchy of status, teach their young and work cooperatively. To capture the very powerful essence of the black phase of the gray wolf, Bateman chose to portray the black animal within almost totally achromatic surroundings.

RESIDES: Fulford Harbour, British Columbia, Canada
EDUCATION: University of Toronto
MAJOR FIELDS: Geography
EXHIBITIONS: *Wildlife in Art*, 1987; *Birds in Art*, 1987-89; *Wildlife Artists of the World*, 1988, The Tryon Gallery, London; *D'Apres Nature*, 1989, Municipal Art Gallery, Luxembourg
AWARDS: Honorary Doctor of Fine Arts, 1989, Colby College, Waterville, Maine
COLLECTIONS: Glenbow-Alberta Institute, Calgary, Alberta; Hamilton Art Gallery, Hamilton, Ontario; Leigh Yawkey Woodson Art Museum
COMMISSIONS: National Fish and Wildlife Foundation, Washington, D.C.
PUBLICATIONS: "The Best Things in Life Are Not Free Anymore," *Wildlife Art News*, March/April 1990
REPRESENTATIVES: Mill Pond Press, Venice, Florida

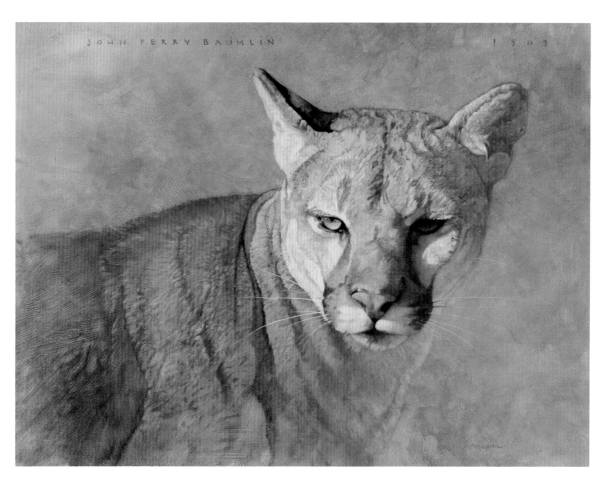

Composing a painting so that it is not a mere representation of a species but instead a portrait study of an individual animal is of primary importance to John Baumlin. This simple, direct depiction of a cougar is indicative of his preoccupation with individuality – the unique little shapes and rhythms found in the fur, for example. The juicy colors of oils and the ability to push the medium around until it is just right enable Baumlin to demonstrate that realism has more to offer than simply finicky detail.

RESIDES: Binghamton, New York
EDUCATION: State University of New York, Delhi
MAJOR FIELDS: Architecture
EXHIBITIONS: *Birds in Art*, 1987-89; *Wildlife in Miniature*, 1988, Wild Wings, Lake City, Minnesota; *Arts for the Parks*, 1988-89, National Park Academy of the Arts, Jackson, Wyoming
AWARDS: Judges' Merit Award, 1989, *Wildlife and Western Art Exhibit*, National Wildlife Art Collectors Society, Minneapolis
BIBLIOGRAPHY: "The New Generation: Five Young Wildlife Artists to Keep an Eye On," *U.S. ART*, March 1990

John Perry Baumlin
b. 1956, United States

Cougar, 1989
Oil on gessoed board
9 x 11½

Collection of the artist

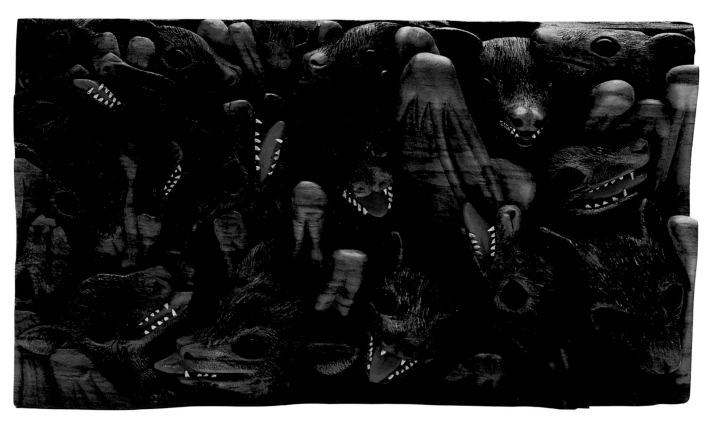

Nancy Blauers
b. 1964, United States

Egyptian Fruit Bats, 1988
Basswood and acrylic
8 x 14 x 4

Collection of the artist

Nancy Blauers is frequently asked, "Why bats?" This question allows her to educate the inquisitive about one of nature's most fascinating and often maligned creatures. "Many have a negative impression of bats due to the myths and fallacies with which these little winged creatures have been saddled. However, bats are among the world's most beneficial mammals. Insect-eating bats can eradicate thousands of mosquitoes in just one night, while fruit- and nectar-eating bats are responsible for seed dispersion and the pollination of most tropical and subtropical vegetation." Blauers' tight grouping of bat heads is well-suited to relief sculpture. The density of forms evokes a chaotic feeling typical of bats in their roost. The animals are extremely animated, almost as if they are squabbling among one another.

RESIDES: Stratford, Connecticut
EDUCATION: School of Visual Arts, New York City
MAJOR FIELDS: Illustration, painting and sculpture
EXHIBITIONS: *Into the Third Dimension*, 1989, Olympia and York Communications, New York City
AWARDS: Donald R. Miller Memorial Award, Interpretive Sculpture, 1989, *Society of Animal Artists*, Boston Museum of Science; Silver Award, *Dimensional Illustrator's Award Show*, 1989, New York City
BIBLIOGRAPHY: "Three-Dimensional Illustration Comes of Age," *American Artist*, September 1989
REPRESENTATIVES: Mystic Maritime Gallery, Mystic, Connecticut; Cinnamon Teal, Essex, Connecticut

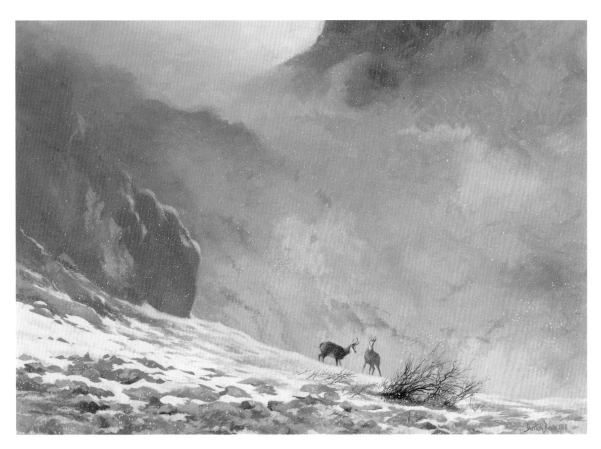

Derick Bown strives to achieve a credible atmosphere in his paintings and leaves the rest to the viewer's imagination. "Chamois live on the timberline where in autumn the weather can change rapidly. When this happens, it is not unusual for the animals to try reaching lower ground. *Chamois in the Snow* portrays just such an episode."

RESIDES: Ibstock, Leicestershire, England
EXHIBITIONS: *Jubilee Exhibition*, 1988, Wildlife Art Promotion, Beusichem, The Netherlands; *Wild in de Natuur*, 1989, Kunsthuis Van Het Oosten, Enschede, The Netherlands
REPRESENTATIVES: Wildlife Art Promotion, Bruinehaar, The Netherlands

Derick Bown
b. 1935, England

Chamois in the Snow, 1988
Gouache on paper on board
10½ x 14½

Private collection

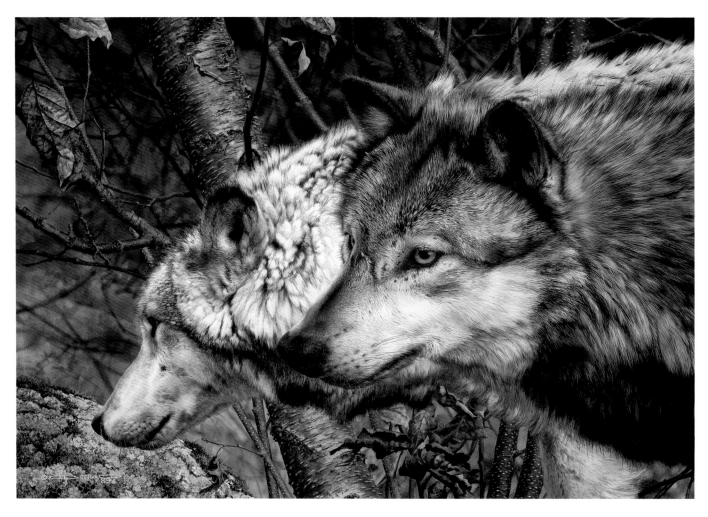

Carl Brenders

b. 1937, Belgium

The Companions, 1989
Timber wolf
Gouache on paper on board
20¼ x 28½

Private collection

"An artist is a privileged being because in his imagination he can come very close to the animals he paints. For the few weeks that I worked on this composition, I felt very close to these two wolves, and little by little they became alive. In reality one can never come this close to wild animals, particularly if they are predators. At one time wolves were found everywhere in the Northern Hemisphere; however, humans have forced the species out of the Northeast. In *The Companions*, I wanted to reintroduce the animal to that region." Carl Brenders has a remarkable ability to subtly utilize the widest range of colors. The tonal differences found in the coats of individual canids provide striking visual contrasts in this work.

RESIDES: Zoersel, Belgium
EDUCATION: Royal Academy of Fine Art, Antwerp
MAJOR FIELDS: Painting and drawing
EXHIBITIONS: *Wildlife in Art*, 1987; *Birds in Art*, 1987-89; *Society of Animal Artists*, 1988, Cumming Nature Center of the Rochester Museum and Science Center, Naples, New York, and 1989, Boston Museum of Science; *Miniatures '88 and '89*, White Oak Gallery, Edina, Minnesota; Trailside Galleries, 1988, Jackson, Wyoming; Prestige Gallery, 1989, Mississauga, Ontario, Canada
BIBLIOGRAPHY: "Regionalism, Home Field Advantage," *Wildlife Art News*, July/August 1988; "Discovering America, Carl Brenders," *U.S. ART*, September 1988; "Protecting Them All," *U.S. ART*, March 1990
REPRESENTATIVES: Christiane Thorn Katcham, Tryon, North Carolina; Mill Pond Press, Venice, Florida

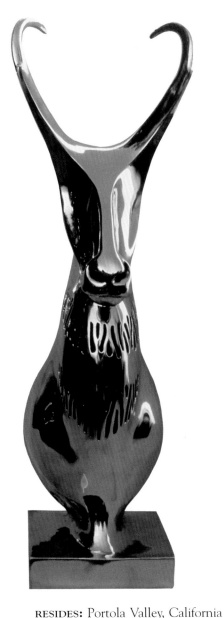

"In order to create images of animals that everyone can enjoy, I like to take chances using a stylized approach. In *Pronghorn Bust*, I employed an uncommon method for me, an anatomical surgeon: This pronghorn has neither eyes nor ears because they seemed unessential and would disrupt the graceful flow of lines I wished to accentuate in portraying the animal's natural beauty. I chose to use stainless steel instead of bronze after I completed the initial plaster model. In white, the frontal view reminded me of a Georgia O'Keeffe painting. This prompted me to select stainless for the final version."

RESIDES: Portola Valley, California
EDUCATION: Chicago Medical School; Loyola University Medical Center, Chicago
MAJOR FIELDS: Reconstructive plastic surgery
EXHIBITIONS: *Society of Animal Artists*, 1988, Cumming Nature Center of the Rochester Museum and Science Center, Naples, New York, and 1989, Boston Museum of Science; *Birds in Art*, 1989
AWARDS: Gold Medal of Honor, 1988, *Allied Artists of America*, New York City
COMMISSIONS: Nature Conservancy, Arlington, Virginia
PUBLICATIONS: *The Artistry of Reconstructive Surgery*, C. V. Mosby Company, 1987
REPRESENTATIVES: Sportsman's Edge/ King Gallery, New York City; Trailside Galleries, Scottsdale, Arizona; The Tryon Gallery, London

Burt Brent
b. 1938, United States

Pronghorn Bust, 1988
Stainless steel
26½ x 7 x 12

Collection of the artist

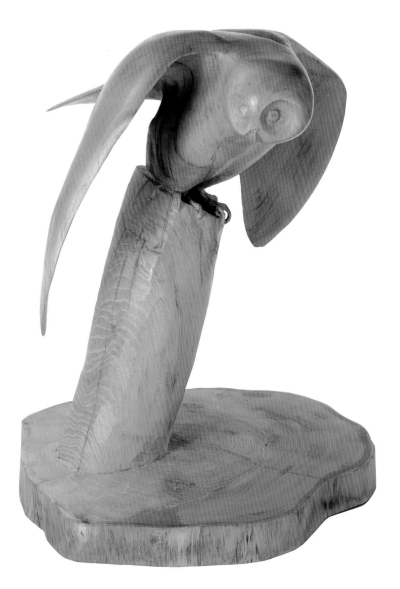

Charles Greenough Chase
b. 1908, United States

Snowy Owl, 1989
Locust
26 x 16 x 16

Private collection

"Chippy" Chase's style is direct, accurate, lifelike. No fanciful elements distract from the drama of the main subject; the bird itself creates a visual vignette. The owl is alert, having just spotted its prey. Its wings are outspread so the wind can lift the bird and carry it on its predatory mission. Chase's mastery is evident in the economy of gesture utilized to convey this message. The snowy owl "appears" real yet without excessive detail. The overall effect is aided by the light brown color of locust wood which suggests the plumage of a female snowy owl.

RESIDES: Brunswick, Maine
EDUCATION: Harvard University, Cambridge, Massachusetts
MAJOR FIELDS: Mathematics
EXHIBITIONS: *Wildlife in Art,* 1987; *Birds in Art,* 1987-89; Chocolate Church Gallery, 1989, Bath, Maine
COLLECTIONS: Everhart Museum, Scranton, Pennsylvania; Farnsworth Library and Art Museum, Rockland, Maine; Leigh Yawkey Woodson Art Museum

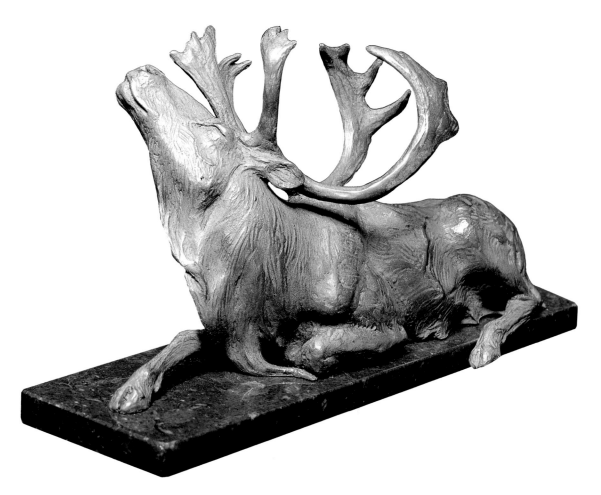

As a big game guide in the Yukon Territory for nine years, Tim Cherry had the opportunity to study caribou every day. *Reclining Caribou* evokes an image of a mountain ridge surrounded by golden autumn colors, capturing a moment of breathtaking beauty and majesty. "I used a gray patina to suggest the coolness of the environment, rubbing in back to the bronze to create a sensation of sunshine upon the animal."

RESIDES: Loveland, Colorado
EXHIBITIONS: *Sculpture in the Park,* 1988-89, Benson Park Sculpture Garden, Loveland; *North American Sculpture,* 1989, Foothills Art Center, Golden, Colorado
AWARDS: First Place Sculpture, 1989, *Western Regional Art Show,* Cheyenne Frontier Days Old West Museum, Cheyenne, Wyoming; Award of Merit, 1989, *National Art Exhibition of Alaska Wildlife,* Anchorage Audubon Society, Anchorage

Tim Cherry
b. 1965, Canada

Reclining Caribou, 1989
Mountain caribou
Bronze
6 x 8 x 3

Collection of the artist

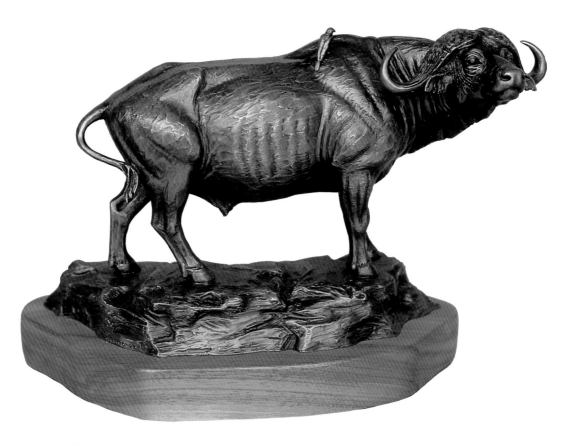

Wendy Christensen-Senk

b. 1963, United States

Cape Buffalo and Tick Bird, 1988
Cape buffalo and
red-billed oxpecker
Bronze
9 x 13 x 6

Collection of the artist

"During a recent research trip to Zimbabwe and South Africa, I observed Cape buffalo and was particularly intrigued by their actions when they discovered an intruder. The buffalo lift their heads high and sight at you as if their noses were the barrel of a gun, while oblivious to the hustle-and-bustle activities of the many tick birds on and around them." *Cape Buffalo and Tick Bird* is Wendy Christensen-Senk's first bronze. "I want to move beyond the attention to detail that my work as a museum taxidermist requires. Here I concentrated more on the buffalo's form by utilizing an abstract texture while still remaining true to the basic subject."

RESIDES: Hales Corners, Wisconsin
EXHIBITIONS: *Milwaukee Public Museum Artists*, 1988, Charles Allis Art Museum, Milwaukee; *Great Lakes Wildlife Art Festival*, 1989-90, Milwaukee
AWARDS: Best of Show, *Wisconsin Taxidermist Association*, 1988-89, Madison, Wisconsin
COLLECTIONS: Milwaukee Public Museum
COMMISSIONS: Milwaukee County Airport
PUBLICATIONS: "Building a Pour Foam Mannequin," *American Taxidermist Magazine*, January/February 1989; "Facial Casts and Death Mask References – The Senk Method," *American Taxidermist Magazine*, November/December 1989
BIBLIOGRAPHY: "Award of Excellence Winner – Wendy Christensen-Senk," *American Taxidermist Magazine*, January/February 1988
REPRESENTATIVES: Pinewood Galleries, Hales Corners, Wisconsin

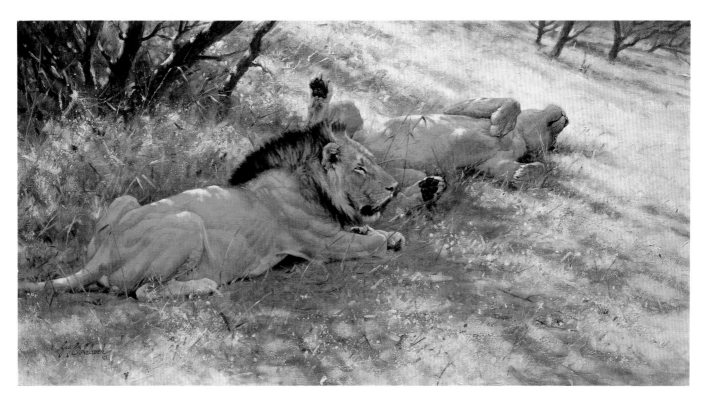

The prowess of lions is legendary and not only limited to confrontations. In fact, the species' romantic endurance and stamina are unparalleled. Guy Coheleach has focused on the contentment of this pair while depicting an incident he observed some years ago in Botswana. This comfortable, almost lazy, pose with paws up in the air suggests a "pause" in activity only just completed. Coheleach has stated this scene simply, utilizing a combination of tight, literal strokes along with a looser, freer presentation.

RESIDES: Bernardsville, New Jersey
EDUCATION: Cooper Union Art School, New York City
MAJOR FIELDS: Design
EXHIBITIONS: *Wildlife in Art*, 1987; *Birds in Art*, 1987-89; *Society of Animal Artists*, 1988, Cumming Nature Center of the Rochester Museum and Science Center, Naples, New York, and 1989, Boston Museum of Science; *Miniatures '89*, White Oak Gallery, Edina, Minnesota
AWARDS: Honorary Doctor of Fine Arts, College of William and Mary, Williamsburg, Virginia
COLLECTIONS: Leigh Yawkey Woodson Art Museum; The White House and U.S. Department of State, Washington, D.C.
BIBLIOGRAPHY: *Painting Birds*, Watson-Guptill Publications, 1988; *Guy Coheleach*, Briar Patch Press, 1988

Guy Coheleach
b. 1933, United States

Paws, 1989
Lion
Oil on linen
24 x 44

Collection of the artist

Michael Coleman

b. 1946, United States

On Vancouver Island, 1989
Black bear
Oil on gessoed board
30 x 46

Collection of Richard Gooding

"The paintings of Michael Coleman are like pictures from an expedition to an unchartered frontier, each charged with the excitement of discovery."* Coleman recounts the motivation for *On Vancouver Island*: "While hunting on the Island for the first time, I was impressed with the atmosphere and colors and the way the bears could be there and then be gone. What a difference a bear made to the landscape!"

RESIDES: Provo, Utah

EDUCATION: Brigham Young University, Provo

MAJOR FIELDS: Art

EXHIBITIONS: *Artists of America*, 1988-89, Colorado History Museum, Denver; J. N. Bartfield Galleries, 1988-89, New York City; *Miniatures '89*, White Oak Gallery, Edina, Minnesota

AWARDS: First National Park Stamp, *Arts for the Parks*, 1988, National Park Academy of the Arts, Jackson, Wyoming

COLLECTIONS: Buffalo Bill Historical Center, Cody, Wyoming; C. M. Russell Museum, Great Falls, Montana; Palm Springs Desert Museum, Palm Springs, California; Wildlife of the American West Art Museum, Jackson

BIBLIOGRAPHY: *"Wild Places, Wide Horizons," Sporting Classics*, June 1988

REPRESENTATIVES: J. N. Bartfield Galleries, New York City

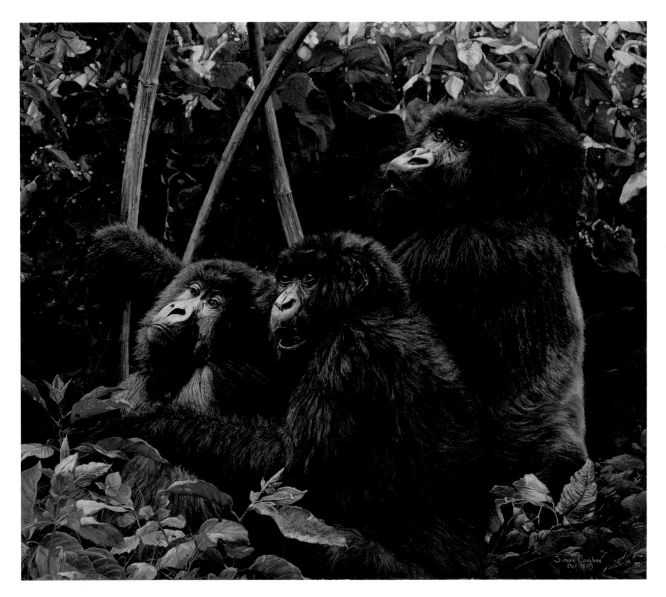

"In 1986 I visited the Parc Des Volcans in northern Ruanda, where Diane Fosse conducted her famous research, and spent memorable and precious moments sitting with one of the mountain gorilla groups that she habituated. After that extremely moving experience, this painting simply had to be done." Simon Combes chose to focus on the apes' extraordinary eyes and facial expressions. "Their features reflect their mild and momentary indignation with me, a clumsy intruder in their domain. My impression was that a similar expression would be forthcoming from diners in an elegant restaurant if a waiter dropped a tray of drinks!"

RESIDES: Tewkesbury, Gloucestershire, England
EXHIBITIONS: *Wildlife in Art,* 1987
PUBLICATIONS: *An African Experience, Wildlife Art and Adventure in Kenya,* Clive Holloway Books, 1989
BIBLIOGRAPHY: "Masai Mara Migration," *Defenders,* March/April 1989; "An Officer and an Artist," *Sporting Classics,* March/April 1989; "Simon Combes: Hair, Dust and Sky," *International Wildlife,* September/October 1989
REPRESENTATIVES: The Greenwich Workshop, Trumbull, Connecticut

Simon Combes
b. 1940, England

Mountain Gorillas, 1988
Oil on linen
32 x 36

Collection of
Paul and Eula Hoff

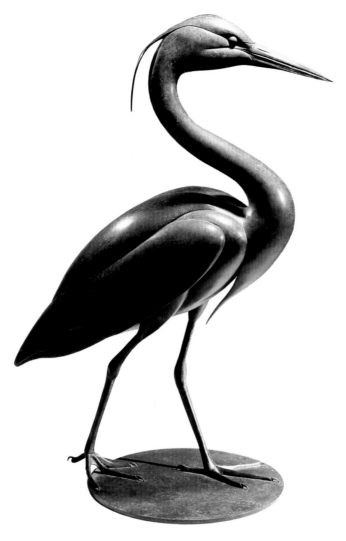

Geoffrey Dashwood
b. 1947, England

Heron, 1989
European gray heron
Bronze
28½ x 19 x 11

Collection of the artist

Geoffrey Dashwood's bronze birds capture the poise and individual characteristics of each species without even the slightest hint of anthropomorphism. His stylized subjects contain no irrelevant surface details, and he has a sure instinct for portraying the most instantly recognizable pose for each bird, such as the sinuous S curve evident here. Dashwood concentrates on pure shape and silhouette, making exceptional use of the sculptural medium. For *Heron*, "just scraping away the eyelids was enough to capture the fishy gaze and glacial reserve of [this bird]."*

RESIDES: Godshill Wood, England
EXHIBITIONS: *Birds in Art*, 1989; *International Contemporary Art Fair*, 1989, London; *Birds*, 1989, Royal Society for the Protection of Birds, Sussex, England; The Sladmore Gallery, 1989, London
COLLECTIONS: Society for Wildlife Art of the Nations, Sandhurst, England
BIBLIOGRAPHY: *Geoffrey Dashwood: Recent Sculpture*, The Sladmore Gallery, London, 1989
REPRESENTATIVES: The Sladmore Gallery, London

A September 1989 visit to the Leigh Yawkey Woodson Art Museum sparked Edward DuRose to explore the indigenous farmlands east of Wausau, Wisconsin. As the sun rose, he came upon a glistening creek punctuating the landscape. The stillness of the scene coupled with the natural light were a must to record. DuRose took artistic license with the addition of the red fox though its presence was entirely plausible.

RESIDES: Roseville, Minnesota
EDUCATION: College of St. Thomas, St. Paul, Minnesota
MAJOR FIELDS: Art
EXHIBITIONS: *Birds in Art*, 1987-89; *Wild Wings Fall Festival*, 1988, Lake City, Minnesota; *Wildlife Art*, 1988-89, Minnesota Wildlife Heritage Foundation, Minneapolis; *Miniatures '89*, White Oak Gallery, Edina, Minnesota
REPRESENTATIVES: Christopher Queen Galleries, Duncans Mills, California; Wild Wings, Lake City, Minnesota

Edward DuRose
b. 1956, United States

Frosty Morning, 1989
Red fox
Acrylic on board
19½ x 36

Collection of the artist

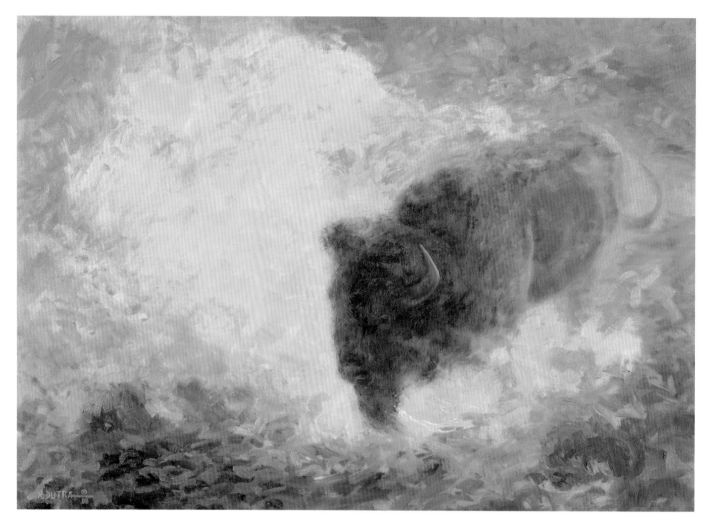

Randal M. Dutra
b. 1958, United States

Dust Devil, 1988
American bison
Oil on canvas
30 x 40

Collection of the artist

"I try to let the subject and its surroundings dictate the artistic approach I will take – whether in paint or bronze. Rather than impose my preference from the onset, I try to openly absorb what I can see before me – then work with the medium that will best communicate my impressions." For *Dust Devil*, Randal Dutra sought to convey the power and weight of the bison as well as to indicate the inherent danger. Developing a textural surface is of interest to Dutra; he selected oil paints to enable the build-up of heavy impasto areas contrasted with thin, leaner patches.

RESIDES: Castro Valley, California
EDUCATION: Art Students League, New York City
MAJOR FIELDS: Art
EXHIBITIONS: *Animal Imagery*, 1988-89, St. Hubert's Giralda, Madison, New Jersey; *Society of Animal Artists*, 1988, Cumming Nature Center of the Rochester Museum and Science Center, Naples, New York, and 1989, Boston Museum of Science; Wildlife of the World Gallery, 1989, Carmel, California
REPRESENTATIVES: Kral Fine Arts, Oakland, California; Masterpiece Gallery, Carmel, California; Wildlife of the World Gallery, Aspen, Colorado

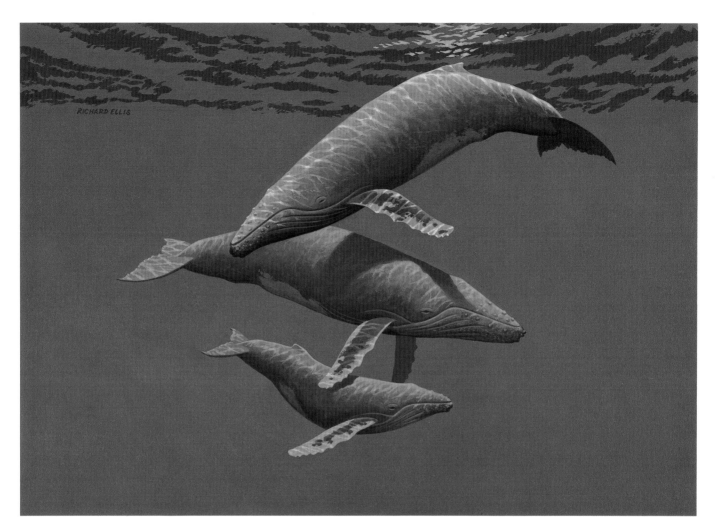

Having dived with humpbacks in Hawaii, Richard Ellis works from a unique perspective in conveying the bulk of the whales and the feeling of clear, warm water. "Fifteen-foot-long flippers give humpbacks a grace rarely evident in such ponderous creatures. Here I utilized a zig-zag pattern; like a falling sheet of paper, the composition swings back and forth from top to bottom, culminating in the baby whale at the base of the pyramid. As for the play of light and shadow, the filtered sunlight flickers in liquid patterns on the cetaceans' broad backs and each whale casts a shadow on the one below. Although most of my paintings employ a blue or green palette, *Humpback Family* is representative of my 'blue period.' Whales are not blue animals; out of the water they are black and white. However, below the surface, where the water absorbs all colors of the spectrum, they appear blue."

RESIDES: New York City
EDUCATION: University of Pennsylvania, Philadelphia
MAJOR FIELDS: American studies
EXHIBITIONS: *Wildlife in Art*, 1987; *Society of Animal Artists*, 1988, Cumming Nature Center of the Rochester Museum and Science Center, Naples, New York
COLLECTIONS: Denver Museum of Natural History; American Museum of Natural History, New York City; New Bedford Whaling Museum, New Bedford, Massachusetts; Whaleworld, Albany, Western Australia
PUBLICATIONS: "The Exhibition of Whales," *Whalewatcher*, Winter 1989

Richard Ellis
b. 1938, United States

Humpback Family, 1988
Humpback whale
Acrylic on canvas
28 x 34

Collection of the artist

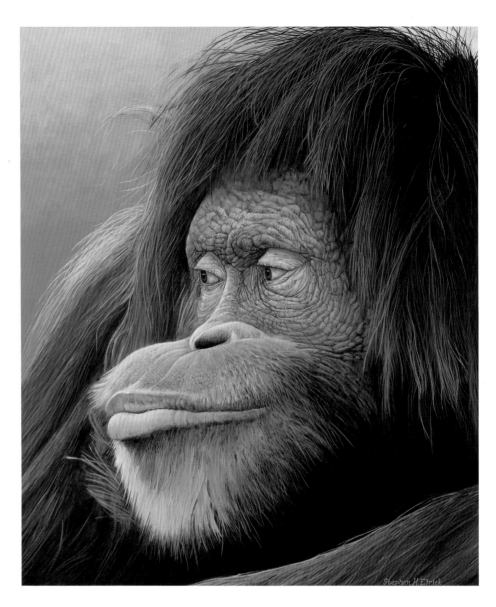

Stephen H. Elrick
b. 1941, United States

Child of the Forest, 1989
Orangutan
Acrylic on board
24 x 20

Collection of the artist

Stephen Elrick has returned again and again to the extreme close-up as a way of taking a fresh look at nature. "*Child of the Forest* challenged my ability to show sorrow and vulnerability on one hand (note the right shoulder thrown up as if a shield) while at the same time showing the pensiveness, bemusement and humor that I found in the orangutan. I did not use a mirror (as many have suggested!) in painting this work, but more than once I did find myself contorting my face to imitate what I thought the subject should be like. I struggled with the hair to suggest disarray while wanting to keep it somewhat soft and flowing. Orangutans are rapidly losing their habitat in the Indonesian wilds, and I tried to project a sadness reflective of this situation and to develop an empathy between the viewer and the subject."

RESIDES: Frankfort, Michigan
EDUCATION: Carleton College, Northfield, Minnesota; University of Chicago
MAJOR FIELDS: Philosophy and social psychology of education
EXHIBITIONS: *Birds in Art*, 1988-89; Elliot Museum, 1988, Stuart, Florida; Back in the Woods Gallery, 1990, St. Petersburg, Florida
COLLECTIONS: Elliot Museum

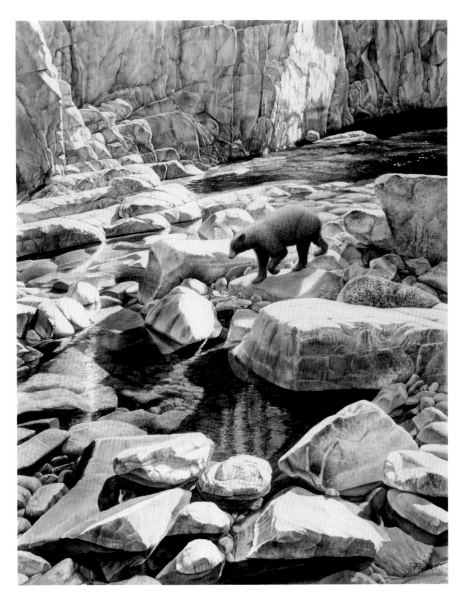

"My art is the result of a love of the land and a need to explore it, coupled with a fascination with my discoveries and an almost childlike exuberance to share what I have discovered with others." For years Janet Tarjan Erl has frequented the river canyons of the Sierra Nevadas. *River and Bear* reflects her attraction to the crystal clear rivers of this area. Their polished rocks evoke a tactile coolness; their deep, shimmering pools invite exploration. In the summertime when the river is at rest, a harmonious balance exists between the rocks, the pools and the bear. To strengthen the design, Erl incorporated a sharp contrast between the bright, white rocks and the water's cooler greens. "I struggled with the rock walls in the background, wanting them to appear true to life with all their varied facets, stains and mosses, while also seeming as though they were shaded. I anguished over whether the rocks were too white or too dark."

RESIDES: Yreka, California
EDUCATION: University of California, Davis; Sierra College, Rocklin, California
MAJOR FIELDS: Fine arts
EXHIBITIONS: *Wild Wings Fall Festival,* 1988, Lake City, Minnesota; *Birds in Art,* 1988-89; *Watercolors,* 1989, Zantman Art Galleries, Carmel, California
AWARDS: Owen J. Gromme Grant, 1990, American Museum of Wildlife Art, Red Wing, Minnesota
COLLECTIONS: Leigh Yawkey Woodson Art Museum; Sacramento Science Center and Junior Museum, Sacramento
PUBLICATIONS: "Painting in the Backcountry, A Guide to Streamlining Your Art Gear," *American Artist,* October 1988
BIBLIOGRAPHY: "Private Showings: Janet Tarjan Erl," *U.S. ART,* April 1989
REPRESENTATIVES: Shasta Wildlife Gallery, Mount Shasta, California; Zantman Art Galleries, Carmel, California

Janet Tarjan Erl
b. 1957, United States

River and Bear, 1989
Black bear
Watercolor on paper
27 x 20¾

Collection of David Erl

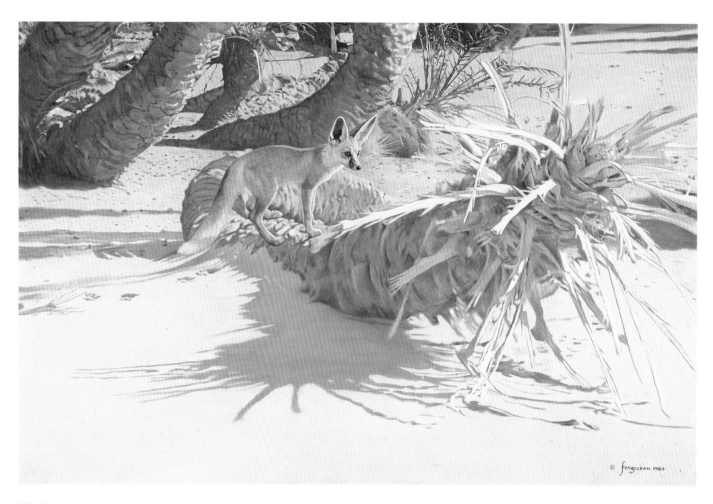

Walter Ferguson

b. 1930, United States

Denizen of the Desert, 1989
Sand fox
Oil on canvas
32 x 46

Collection of the artist

An interesting subject ignites Walter Ferguson's creative energies, and his fascination with nature's variety is reflected in the range of subjects he has tackled, from gazelles to Beduins. His working method involves a selection process through which he "is able to compare things and make the viewer focus on what he desires. He is also able to compensate for all sorts of limitations. The range of light and color is available to the artist through the palette. The artist is able to exaggerate colors, shapes, forms and perspective in a way not obviously exaggerated, lest it become grotesque."* Ferguson uses his work to encourage public interest in wildlife conservation, a difficult task in a land where the people themselves struggle to survive.

RESIDES: Beit Yanai, Israel
EDUCATION: Yale University, New Haven, Connecticut; Pratt Institute, Brooklyn, New York
MAJOR FIELDS: Fine arts
EXHIBITIONS: *Birds in Art*, 1987; United States of America Cultural Center, 1988, Tel Aviv, Israel; *Society of Animal Artists*, 1989, Boston Museum of Science
AWARDS: First Prize, 1988, Third World Conference on Birds of Prey, Eilat, Israel
COLLECTIONS: American Museum of Natural History, New York City; Israel Museum, Jerusalem; Tel Aviv University
BIBLIOGRAPHY: "A Different Kind of Pioneer," *Eretz Magazine*, Autumn 1988; *"Artist Vignette: Walter Ferguson," *Wildlife Art News*, March/April 1989
REPRESENTATIVES: Fine Art Impressions, La Mesa, California; Kohl Galleries, Upland, California

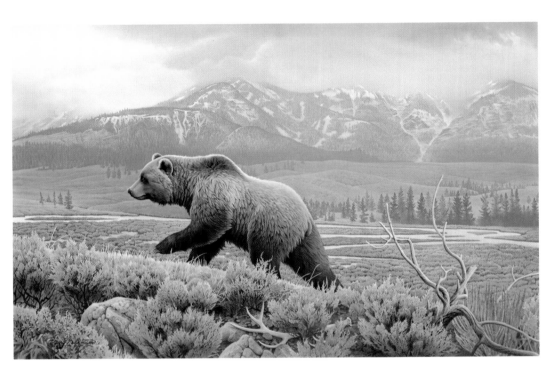

The grizzly bear and the wilderness are synonymous for Jerry Gadamus. His intent in *Yellowstone Mist* was to translate the precarious state of both into a two-dimensional image. Gadamus's ability to achieve accurate detail adds to his desired effect. His mastery of the technique of "free-hand" airbrush enables him to work without the aid of stencils, masking or paintbrushes.

RESIDES: Iola, Wisconsin
EDUCATION: University of Wisconsin, Stevens Point
MAJOR FIELDS: Art
EXHIBITIONS: *Birds in Art*, 1987 and 1989; *Seven Artists*, 1989, Landmarks Gallery, Milwaukee; *Plein Air Painting Expedition*, 1989, Wilderness Legends Gallery, Minocqua, Wisconsin
AWARDS: Sponsor Artist, 1988, National Society to Prevent Blindness, Milwaukee; Artist of the Year, 1990, Wisconsin Waterfowlers Association; Northern Mississippi Flyway Artist, 1990-91, Wisconsin Ducks Unlimited
REPRESENTATIVES: Northwoods Craftsman, Menomonee Falls, Wisconsin

Jerry Gadamus
b. 1947, United States

Yellowstone Mist, 1989
Grizzly bear
Acrylic on board
26 x 40

Courtesy of Wildlife Images, Thiensville, Wisconsin

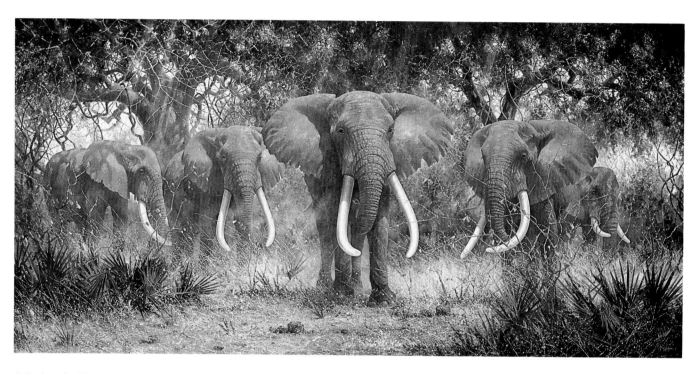

Michael Ghaui
b. 1950, Tanzania

Wise Old Tuskers, 1989
African elephant
Oil on canvas
40 x 80

Collection of the artist

Michael Ghaui's skill and finesse as demonstrated in *Wise Old Tuskers* are such that the viewer can almost "smell" the elephants and "feel" the rough texture of the animals' hides. "I painted this picture primarily because I like elephants, but I also wanted to record what was once a fairly common sight – big bull elephants peacefully moving through the bush. Sadly, it would be difficult to experience this today."

RESIDES: Naivasha, Kenya
EDUCATION: Wye College of London University
MAJOR FIELDS: Agriculture
EXHIBITIONS: *Wildlife in Art*, 1987; *Birds in Art*, 1988-89; *Wildlife Artists of the World*, 1988, The Tryon Gallery, London; *GameCoin*, 1989, Game Conservation International, San Antonio, Texas; *A Farewell to the Eighties*, 1989, Corpus Christi Gallery, Corpus Christi, Texas
PUBLICATIONS: "A Safari to the Bush," *GameCoin*, Summer 1989
BIBLIOGRAPHY: "Michael Ghaui," *Wildlife Art News*, July/August 1988
REPRESENTATIVES: Corpus Christi Gallery, Corpus Christi, Texas; Sportsman's Edge/King Gallery, New York City; Mill Pond Press, Venice, Florida; The Tryon Gallery, London

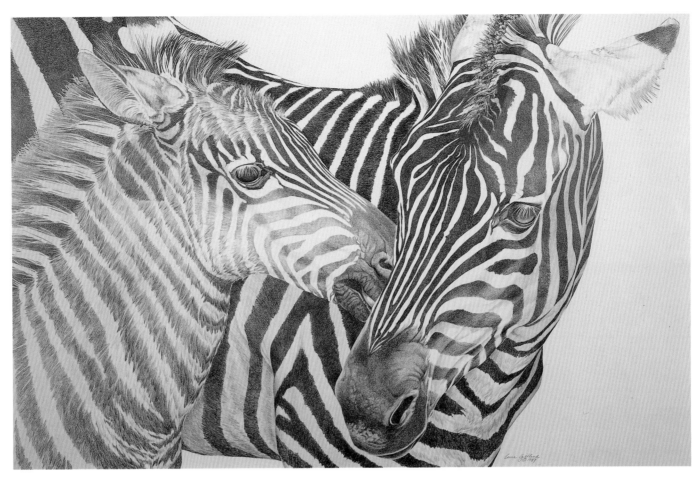

Laura Gilliland is fascinated by bonds, both learned and instinctive, between mother and youngster. This interest in combination with her penchant for nature's patterns and shapes made the zebra an irresistible subject. "*From A to Z* captures an illusive bond between the mother and offspring. Considering the 'born on the run' life of a young zebra, a tender moment such as this is indeed transitory. The title represents all that the youngster must learn in order to survive. I have always liked images that portray a special instant in time, images that make me feel that if I look away, they will be lost – the zebra will have run away." The size of this piece was a challenge for Gilliland. "Pencil is a slow, painstaking medium. I had to search deeply for the discipline to maintain the same standard from start to finish."

RESIDES: Mount Solon, Virginia
EDUCATION: Louisville School of Art, Louisville, Kentucky; University of Miami, Coral Gables, Florida
MAJOR FIELDS: Printmaking and photography
EXHIBITIONS: *Birds in Art*, 1988; *National Art Exhibition of Alaska Wildlife*, 1988-89, Anchorage Audubon Society, Anchorage
AWARDS: Best of Show, 1988, *Juneau Audubon Society Exhibition*, Anderson Gallery, Juneau, Alaska
COLLECTIONS: Alaska Pacific University, Anchorage; Anchorage Museum of History and Art; Tesoro Alaska Petroleum Company, Anchorage
COMMISSIONS: Fairbanks Symphony Association, Fairbanks, Alaska; KHAR Radio, Anchorage
REPRESENTATIVES: Artique Limited, Anchorage; New Horizons Gallery, Fairbanks, Alaska

Laura Gilliland
b. 1953, United States

From A to Z, 1989
Common zebra
Graphite and colored pencil
on illustration board
30 x 40

Collection of the artist

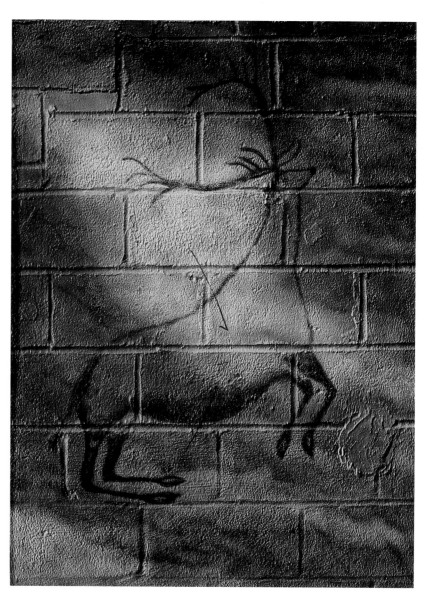

Nolan Haan

b. 1948, United States

Urban Cave Painting IV: Wounded Stag, 1989
Acrylic on silk
60 x 40

Collection of the artist

Urban Cave Painting IV: Wounded Stag represents a new direction for Nolan Haan. "I am fascinated by the juxtaposition of early art forms on a modern building material, as though one had discovered an archaeological site in the basement. Primitive art on cinder block on silk – three surprises in one painting." Haan's challenge was to achieve a convincing cinder block wall, and it required four months of experimentation with numerous techniques and materials. His efforts reflect the advice of artist Carlos Cobos: "The basic rule in contemporary art is 'There are no rules.' "

RESIDES: Bethesda, Maryland
EDUCATION: Albright College, Reading, Pennsylvania
MAJOR FIELDS: Biology
EXHIBITIONS: *Waterfowl Festival*, 1988, Easton, Maryland; *Southeastern Wildlife Exposition*, 1988, Charleston, South Carolina; *Northeastern Wildlife Exposition*, 1988, New York State Museum, Albany; *Federal Duck Stamp Competition Finalist Tour*, 1988; *Wildlife West Festival*, 1988-89, San Bernardino County Museum, Redlands, California
PUBLICATIONS: "One Over the Limit," *Wildlife Art News*, March/April 1990

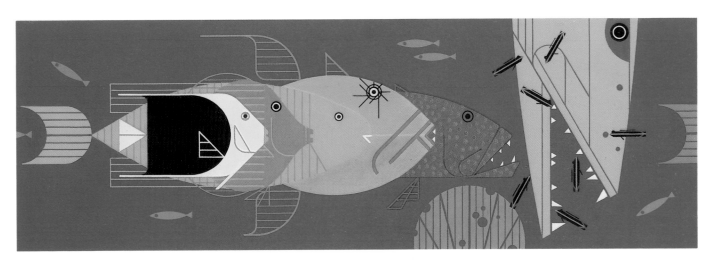

Charley Harper believes that pictures and words together can express an idea more fully than either alone, and that a word can be worth a thousand pictures. "*Piscine Queues*: If you can't brush after every meal, better queue up regularly at the local cleaning clinic. Tiny neon gobies make a good living as dental and dermatological technicians for residents of the reef as they dine on ectoparasites that thrive on tooth, gill and scale, venturing fearlessly into fang-filled caverns to ply their trade. Look! In the barracuda's mouth! Is that goby psychotic? No, just symbiotic. It's mutually beneficial. And the clients tip big – they never gobble the gobies. You might say they always mind their p's 'n' q's."

RESIDES: Cincinnati, Ohio
EDUCATION: Cincinnati Art Academy; Art Students League, New York City
MAJOR FIELDS: Painting
EXHIBITIONS: *Birds in Art*, 1988; *Birds in Art: An Ohio Perspective*, 1989, Cincinnati Museum of Natural History
COLLECTIONS: Cincinnati Museum of Natural History
REPRESENTATIVES: Frame House Gallery, Houston, Texas

Charley Harper
b. 1922, United States

Piscine Queues, 1989
Serigraph on paper
12 x 28

Collection of the artist

Janet N. Heaton
b. 1936, United States

Surviving in Shadows, 1989
African elephant
Chalk pastel on rag paper
22 x 30

Collection of the artist

Years of observing, studying and photographing the African elephant led Janet Heaton to create *Surviving in Shadows* in the hope that viewers would think about the possible extinction of these creatures. "I usually look for large abstract forms and work the animals within these forms – pulling and pushing them with lights and darks to produce continuity within the painting. The challenge here was recognizing that the elephants in the shadows had to appear just as strong, if not stronger, than those in the bright light – realizing it and then making it work on paper."

RESIDES: North Palm Beach, Florida
EDUCATION: Florida State University, Tallahassee
MAJOR FIELDS: Political science
EXHIBITIONS: *Birds in Art*, 1988; *Society of Animal Artists*, 1988, Cumming Nature Center of the Rochester Museum and Science Center, Naples, New York, and 1989, Boston Museum of Science; *Original Art Showcase*, 1989, Prestige Gallery, Mississauga, Ontario, Canada
COLLECTIONS: Leigh Yawkey Woodson Art Museum; Professional Golf Association National, Palm Beach Gardens, Florida; President Arap Moi, State House, Nairobi, Kenya
BIBLIOGRAPHY: "A Painting Safari Through Southern Africa," *American Artist*, September 1988; "Janet Heaton: OU's Featured Artist," *Outdoors Unlimited*, February 1989
REPRESENTATIVES: Heaton Studio and Gallery, Lake Park, Florida

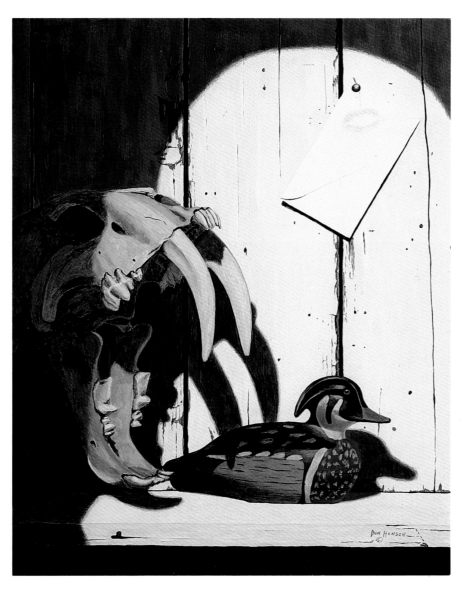

Still life has long been the vehicle of expression for Don Henson's preoccupation with the environment, its inhabitants, and man's impact upon both. Perhaps his focus has been aided by his early study of archaeology and anthropology. Regardless, Henson's characteristic compositional devices and *trompe l'oeil*-like handling contribute to the effectiveness of *Kiss of Death*. "The saber-toothed tiger is, of course, extinct. While wood ducks were probably not regular table fare of this tiger, they had their own brush with extinction. Both faced the onslaught of man – one in the past and one very recently."

RESIDES: Manistique, Michigan
EDUCATION: Southern Illinois University, Carbondale
MAJOR FIELDS: Archaeology and anthropology
EXHIBITIONS: *Birds in Art,* 1987-89; St. Paul's Lutheran Church, 1988, Hillsboro, Illinois
AWARDS: William Meyerowitz Memorial Award, 1989, *Allied Artists of America,* American Academy and Institute of Arts and Letters, New York City
COLLECTIONS: Leigh Yawkey Woodson Art Museum; Montgomery Museum of Fine Arts, Montgomery, Alabama; National Academy of Design, New York City
REPRESENTATIVES: Gray Stone Press, Nashville, Tennessee

Don Henson
b. 1945, United States

Kiss of Death, 1989
Saber-toothed tiger and wood duck
Acrylic on board
26 x 21

Collection of Chris Hronis

Nancy Howe
b. 1950, United States

Full Deck, 1988
Mallard
Acrylic on board
12 x 14

Collection of the artist

Nest scenes and young birds are particularly attractive to Nancy Howe. In designing *Full Deck*, she worked to keep it simple yet fun. Her intimate and playful view of mallard ducklings emphasizes a tender, warm, motherly environment. "I wanted to enhance the overall feeling of softness and comfort while at the same time providing a color and textural contrast with the subject matter. While interesting in its own right, the detailed and realistic background should not draw attention away from the birds."

RESIDES: East Dorset, Vermont
EDUCATION: Middlebury College, Middlebury, Vermont
MAJOR FIELDS: Studio art
EXHIBITIONS: *Arts for the Parks*, 1988, National Park Academy of the Arts, Jackson, Wyoming; *Fall Open Exhibition*, 1988, Southern Vermont Art Center, Manchester; Chaffee Art Center, 1988, Rutland, Vermont; *Wildlife Art*, 1989, Vermont Institute of Natural Science, Woodstock
REPRESENTATIVES: Capricorn Galleries, Bethesda, Maryland

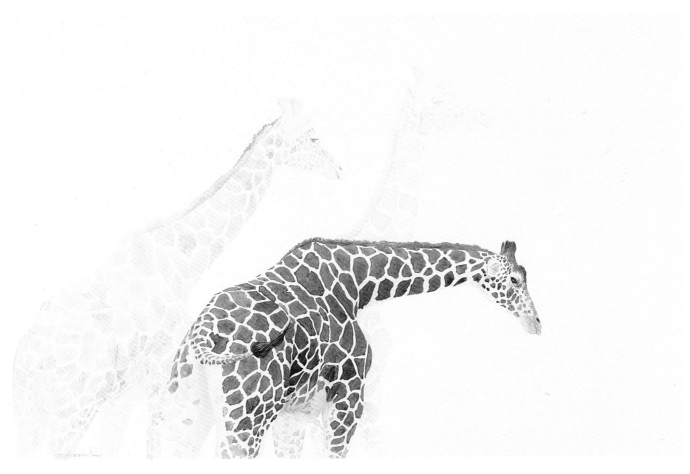

Cary Hunkel strives for simplicity in her work. A desire to emphasize the shapes in *Trinity* rather than linear detail led to the use of watercolor rather than charcoal and colored pencil. Hunkel's design of the three giraffes focuses on their watchful eyes. Movement is suggested by the interconnection of the three animals and their natural stances – poised to go. While accurately portrayed, Hunkel's work also has an abstract feel, the result of compositional decisions and the enhancement of some areas and features while others fade out.

RESIDES: Madison, Wisconsin
EDUCATION: University of Wisconsin, Madison
MAJOR FIELDS: Drawing and printmaking
EXHIBITIONS: *Birds in Art*, 1987-88; *Visions of Nature: Wildlife Art*, 1988, Harry Nohr Gallery, Platteville, Wisconsin; *Miniatures*, 1989, Field Mouse Wildlife Gallery, Ganges, British Columbia, Canada
AWARDS: Award of Merit, 1988, *National Art Exhibition of Alaska Wildlife*, Anchorage Audubon Society, Anchorage
COLLECTIONS: State Historical Society of Wisconsin, Madison; University of Wisconsin Hospital and Clinics, Madison
COMMISSIONS: Madison Audubon Society

Cary Hunkel
b. 1945, United States

Trinity, 1989
Reticulated giraffe
Watercolor on board
19 x 29

Collection of the artist

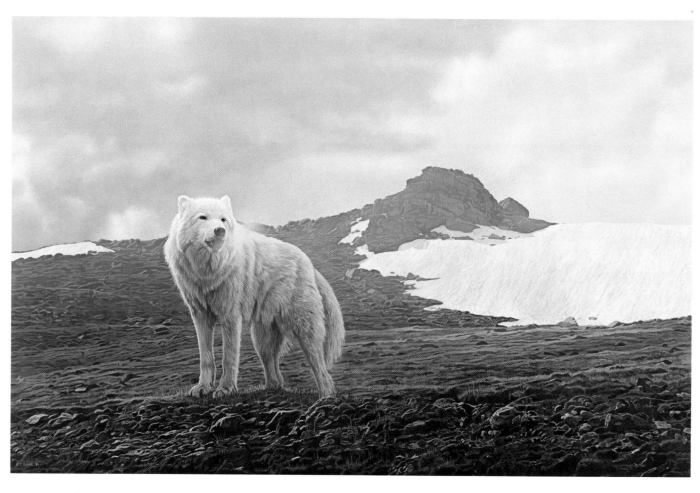

Terry A. Isaac
b. 1958, United States

Tundra Song, 1989
Arctic wolf
Acrylic on board
24 x 36

Private collection

The initial arrangement of the pictorial elements of a painting preoccupies Terry Isaac. "For *Tundra Song,* I first painted a study that included three wolves; then I did many sketches trying different poses and numbers of wolves in an Arctic setting." The final work conveys the beauty, dignity, solitude and sense of wildness that the Arctic wolf embodies as well as the authenticity of the fragile, frigid tundra environment. "At present the Arctic ecosystem is relatively untouched by man. Both this terrain and its wildlife could remain viable if the public becomes sensitized and more informed."

RESIDES: Salem, Oregon
EDUCATION: Western Oregon State College, Monmouth
MAJOR FIELDS: Art education
EXHIBITIONS: *Birds in Art,* 1987-89; *Miniatures '88* and *'89,* White Oak Gallery, Edina, Minnesota; Soaring Wings Gallery, 1988, Eugene, Oregon; *Original Art Showcase,* 1989, Prestige Gallery, Mississauga, Ontario, Canada; Pacific Wildlife Galleries, 1989, Lafayette, California
AWARDS: Featured Artist, 1989, *Pacific Rim Wildlife Art Show,* Tacoma, Washington
BIBLIOGRAPHY: "Artist Vignette: Terry Isaac," *Wildlife Art News,* July/August 1988; "Terry Isaac: Getting Into Particulars," *U.S. ART,* November 1989
REPRESENTATIVES: Mill Pond Press, Venice, Florida; Pacific Wildlife Galleries, Lafayette, California; Soaring Wings Gallery, Eugene, Oregon; Wild Wings Gallery, Seattle, Washington

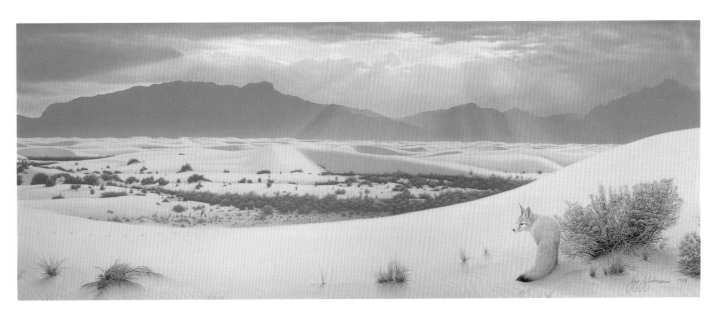

"During a late afternoon visit to White Sands National Monument, New Mexico, ominous rain clouds suddenly broke. Shafts of sunlight illuminated an apparently vast and lifeless expanse of dunes beneath the San Andres Mountains. However, tracks in the sand had other stories to tell – trails of kit fox and dimples where rodents had played. Even here in a locale where the land itself blows away with the wind, life had found a sure foothold." Jay Johnson celebrates the scope and magnitude of the natural world in *Kit Fox at White Sands*. "The natural environment is nearly always as important as the wildlife in my paintings, and here at White Sands it becomes even more important."

RESIDES: Marblehead, Massachusetts
EDUCATION: Cornell University, Ithaca, New York
MAJOR FIELDS: Entomology

Jay J. Johnson
b. 1958, United States

Kit Fox at White Sands, 1989
Kit fox and Ord's kangaroo rat
Acrylic on illustration board
12 x 29¼

Collection of the artist

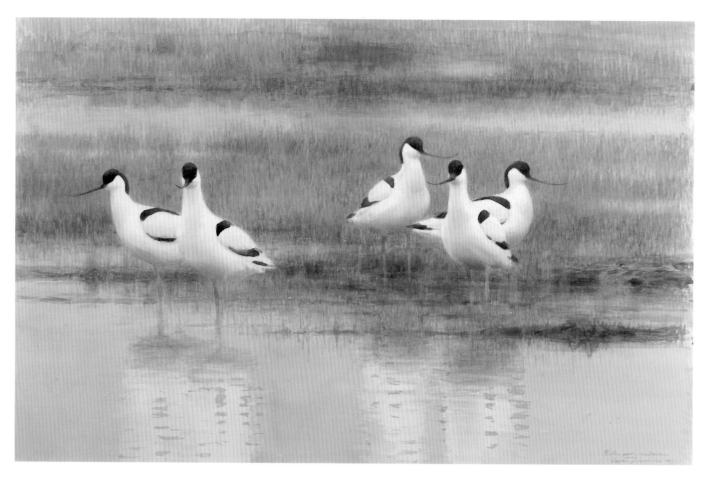

Lars Jonsson
b. 1952, Sweden

Forming Couples, 1988
European avocet
Watercolor on Arches paper
32 x 48

Private collection

Despite long hours spent in the field observing and sketching, actually "finding" the right composition continues to be a struggle for Lars Jonsson. His quest is to capture the dichotomy of birds in their natural habitat: the remarkable harmony as well as the underlying tension evident in *Forming Couples*.

RESIDES: Hamra on Gotland, Sweden
EXHIBITIONS: *Wildlife in Art*, 1987; *Birds in Art*, 1987-89; *Wildlife Artists of the World*, 1988, The Tryon Gallery, London; *D'Apres Nature*, 1989, Municipal Art Gallery, Luxembourg; *Art on Gotland*, 1989, Gotlands Koonstmuseum, Visby
AWARDS: Master Wildlife Artist, 1988, *Birds in Art*
COLLECTIONS: Beijer Collection, Stockholm; Leigh Yawkey Woodson Art Museum
BIBLIOGRAPHY: "Artist of the Year," *Julstämning*, Autumn 1989
REPRESENTATIVES: Mill Pond Press, Venice, Florida; The Tryon Gallery, London

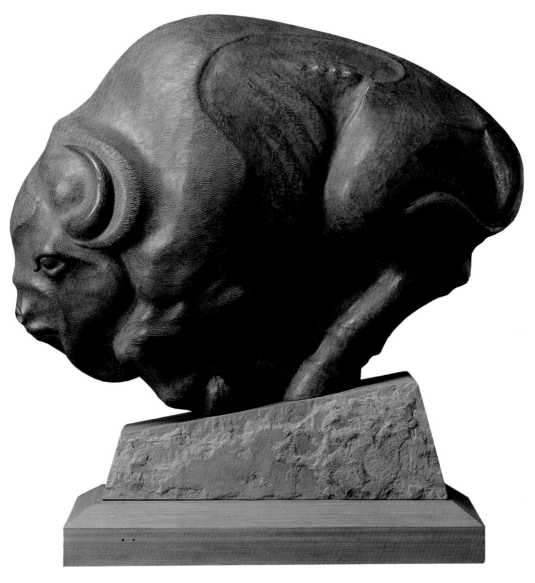

"My goal was to capture the vitality, strength and purity of the bison's ancient lineage in a simplified archetypal image. I struggled to keep the forms simple and had difficulty deciding on the final surface. I worked first with a hard clay so that I could experiment with various portions of the bison's anatomy and with different textures. To achieve the surface I wanted, it was necessary to make all the tools by hand." Steve Kestrel chose to cast *Spectre of Ancient Pathways* in bronze for the terra cotta-like patina he could achieve. For Kestrel the bison inspires awe mixed with reverence for a beast that has quietly run through eons of time with its strength and integrity still intact.

RESIDES: Fort Collins, Colorado
EDUCATION: Colorado State University, Fort Collins
MAJOR FIELDS: Natural sciences and art
EXHIBITIONS: *Birds in Art*, 1988; *National Sculpture Society*, 1988-89, New York City; *North American Sculpture*, 1989, Foothills Art Center, Golden, Colorado
AWARDS: Tallix Foundry Award, *National Sculpture Society*, 1988, New York City
COLLECTIONS: Leigh Yawkey Woodson Art Museum
COMMISSIONS: Benson Park Sculpture Garden, Loveland High Plains Arts Council, Loveland, Colorado
BIBLIOGRAPHY: "Steve Kestrel," *Southwest Art*, July 1989
REPRESENTATIVES: American Legacy Gallery, Kansas City, Missouri; Bishop Gallery, Allenspark, Colorado, and Scottsdale, Arizona; Carol Siple Gallery, Denver; Quast Gallery, Taos, New Mexico

Steve Kestrel
b. 1947, United States

Spectre of Ancient Pathways, 1989
American bison
Bronze
36 x 34 x 12

Collection of the artist

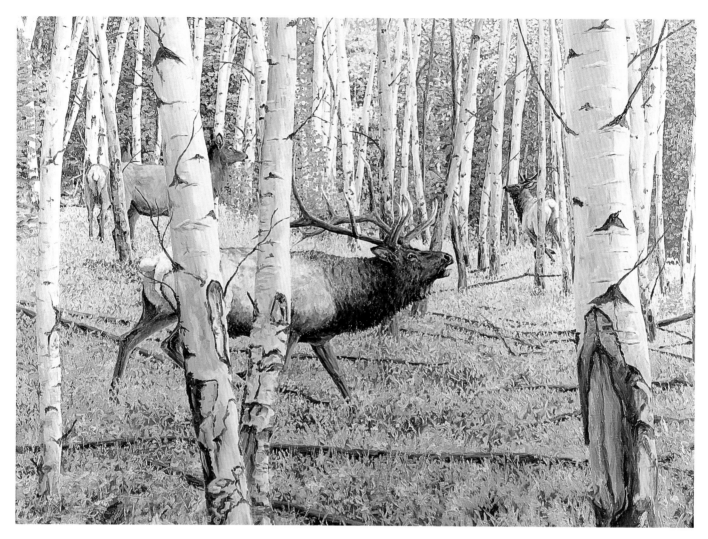

Chuck Kneib

b. 1951, United States

Chasing the Outriders, 1989
Elk
Oil on canvas
30 x 40

Collection of
Mr. and Mrs. Lysle S. Sherwin

Chuck Kneib's appreciation of unspoiled nature is paramount; he would never consider including a fence – evidence of human intrusion – in a painting. "I have spent a good portion of my life outdoors, hunting, fishing, guiding and trapping – just about anything to keep me outside. I have watched all kinds of animals at all times of the year. I know how they behave and react. These are the personal experiences I draw upon and incorporate into my work." When using larger canvases as in *Chasing the Outriders*, Kneib often finds it difficult to know when to restrict or limit the detail in order to keep the subject from appearing overworked.

RESIDES: Billings, Montana
EDUCATION: Missouri Western State College, St. Joseph; University of Montana, Missoula
MAJOR FIELDS: Architecture and geology
EXHIBITIONS: *National Wildlife Art Show*, 1989, Ducks Unlimited, Kansas City, Missouri; *Masters Art Show*, 1989, Loyalhanna Watershed Association, Ligonier, Pennsylvania

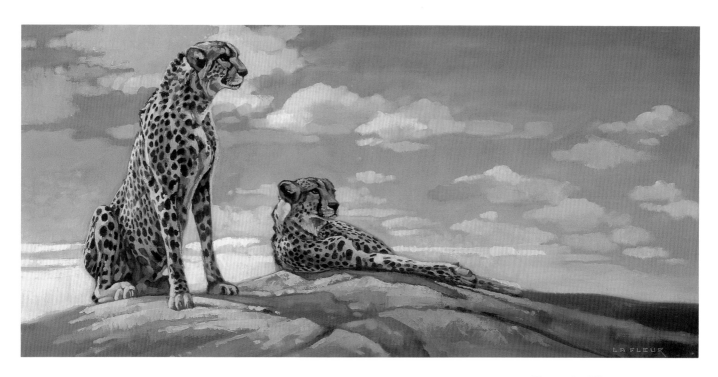

Dave LaFleur creates straightforward paintings of nature. A sense of things to come "fills the air" in *The Day's Work Ahead*. There are implied tasks to be done and an obvious tension and anticipation emanating from the cheetahs as they prepare to start their day. The focal point of the composition is the dramatic contrast between the directed gaze of the cheetahs and the infinite vista of rock and sky. LaFleur has created a symbol of both the power and reality of the day-to-day existence of the wild cat.

RESIDES: Derby, Kansas
EDUCATION: Colorado Institute of Art, Denver
MAJOR FIELDS: Illustration and design
EXHIBITIONS: *1989 New York Society of Illustrators*, New York City; *1989 Los Angeles Society of Illustrators*, Los Angeles; *1989 Japanese Creators' Association*, Tokyo

Dave LaFleur
b. 1961, United States

The Day's Work Ahead, 1989
Cheetah
Oil on canvas
18 x 36

Collection of the artist

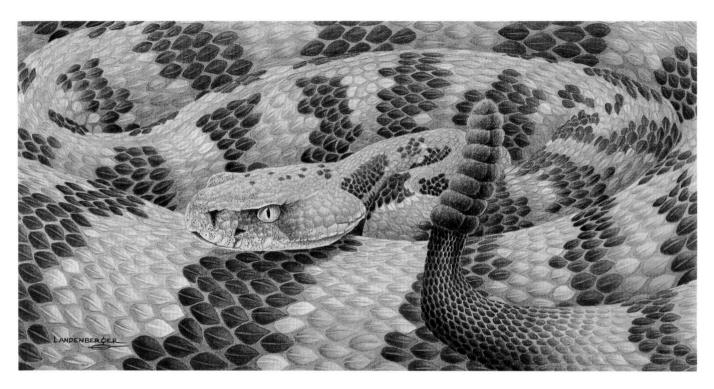

James F. Landenberger
b. 1938, United States

Don't Tread on Me, 1989
Timber rattlesnake
Watercolor on Fabriano paper
6¼ x 12¼

Collection of the artist

At first glance James Landenberger's transparent watercolor could appear as an abstract pattern covering the entire surface of the paper. A more careful look reveals the cold, intense, unblinking stare of a camouflaged predator. *Don't Tread on Me* commands "respect," as would an actual encounter with a timber rattler. For years Landenberger and a friend relocated dens of these snakes in eastern Iowa in an effort to save them from extinction. These undertakings resulted in numerous sketches, the last of which served as the basis for this watercolor.

RESIDES: Cedar Rapids, Iowa
EDUCATION: University of Iowa, Iowa City; Coe College, Cedar Rapids
MAJOR FIELDS: Ornithology, zoology and botany
EXHIBITIONS: *Original Wildlife Art in Iowa,* 1989, Hearst Center for the Arts, Cedar Falls; *Wildlife Art,* 1989, North American Endangered Species Foundation, Denver; *Wildlife in Art,* 1989, Iowa Natural Heritage Foundation, Cedar Falls
AWARDS: Iowa Governor's Volunteer Award, 1988; Artist of the Year, 1988, Iowa Wildlife Federation
COLLECTIONS: Funk Seeds International, Bloomington, Illinois; Archer Daniels Midland, Decatur, Illinois
COMMISSIONS: University of Iowa; Iowa Department of Natural Resources, Des Moines
REPRESENTATIVES: Pawnee Creek Press, Cedar Rapids, Iowa

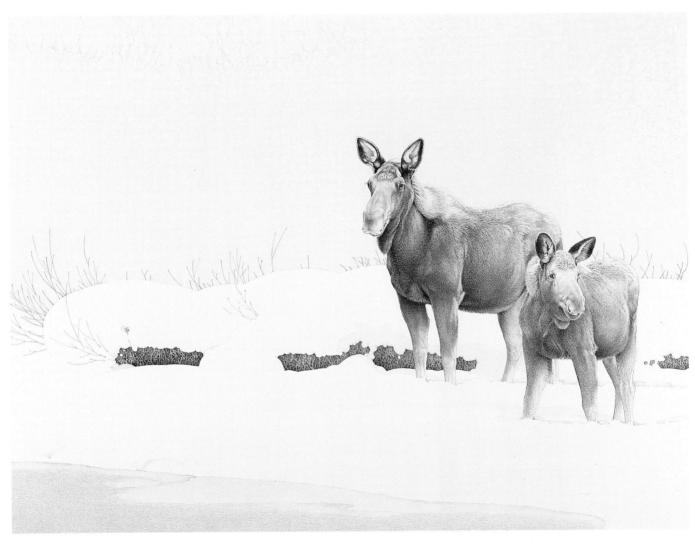

"Along the Wind River or in the Snake River Valley, it is a common experience to meet moose among the willows. The cow is usually accompanied by her spring calf." Laney has experienced this scene many times. Utilizing the subtle effects of transparent watercolor, she has created a unity between the light-colored background and the darker colors of the more detailed animals. The quiet atmosphere of *Valley Residents* depicts the gentle side of nature that Laney prefers to show. "The moose seem to pass through the landscape without sound, their muffled presence suggesting their dignity and grace."

RESIDES: Dubois, Wyoming
EDUCATION: Denver University
MAJOR FIELDS: Advertising and book illustration
EXHIBITIONS: *Birds in Art*, 1988; *Governor's Western and Wildlife Art Show*, 1988, North Platte, Nebraska; *Non-Member Show*, 1989, Salmagundi Club, New York City; *Artists of the West*, 1990, Colorado Springs Pioneers' Museum
AWARDS: Best of Show, 1988, *Wyoming Audubon Show*, Lander, Wyoming; Wildlife Art Award, 1988-89, Wind River Valley Artists' Guild, Dubois; Merit Award, 1989, *National Art Exhibition of Alaska Wildlife*, Anchorage Audubon Society, Anchorage
COLLECTIONS: Wyoming State Museum, Cheyenne
BIBLIOGRAPHY: "Artist Vignette: Laney," *Wildlife Art News*, July/August 1989
REPRESENTATIVES: Wyoming Gallery, Jackson, Wyoming

Laney
b. 1942, United States

Valley Residents, 1989
Moose
Watercolor on Arches paper
18 x 24

Collection of
Budd and Emi Betts

Rod Lawrence
b. 1951, United States

Along the Creek, 1989
White-tailed deer
Acrylic on board
14 x 18

Collection of Robert Faull

Rod Lawrence often retreats to a cedar swamp near his home for inspiration, reference material and tranquility. There he frequently sees white-tailed deer. *Along the Creek* represents this peaceful world. Lawrence has chosen to integrate the deer into the landscape instead of making it the focal point of the composition. "I wanted to convey the same physical feelings that I get when I withdraw to the snowy swamp: the coolness of the air, the dampness along the creek, and the warmth of the sun filtering through the trees. More important, I sought that magical, emotional union that occurs when one observes wildlife in a natural setting without their awareness of a human presence."

RESIDES: Kalkaska, Michigan
EDUCATION: University of Michigan, Ann Arbor
MAJOR FIELDS: Art
EXHIBITIONS: *Miniatures '89,* White Oak Gallery, Edina, Minnesota
AWARDS: Michigan Duck Stamp, 1990
BIBLIOGRAPHY: "A Wildlife Artist," *The Who's Who Entertainer,* November 1988; "Rod Lawrence's Wild World," *Traverse Magazine,* November 1989
REPRESENTATIVES: Mill Pond Press, Venice, Florida

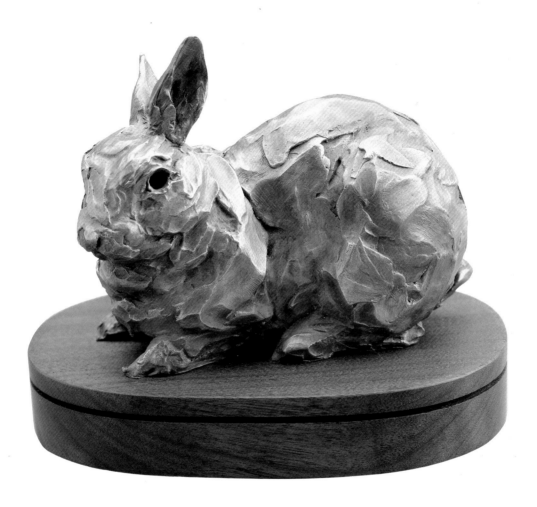

Robin Laws' farm in rural Fort Morgan, Colorado, provides the inspiration for her sculpture. Among her menagerie are three rabbits named Thumper, Callie and Lopp. Laws wants to share her feelings about animals and to this end she infuses each work with a sense of joy. *Another Gray Hare* is no exception: quiet, unobtrusive and diminutive. The silver patina approximates the animal's natural color and contributes to the genuine feeling of the bronze.

RESIDES: Fort Morgan, Colorado
EXHIBITIONS: *Western Regional Art Show*, 1988-89, Cheyenne Frontier Days Old West Museum, Cheyenne, Wyoming; *Catherine Lorillard Wolfe Art Club*, 1988-89, National Arts Club, New York City; *Auction of Original Art*, 1989, C. M. Russell Museum, Great Falls, Montana
AWARDS: Art Fest Award, 1988, *American Artists Professional League*, Salmagundi Club, New York City; Artist of the Year, 1989, Colorado Ducks Unlimited; Katherine Lane Weems Memorial Award, 1989, National Arts Club
COLLECTIONS: Public Service Company of Colorado, Brush; Fort Morgan Museum, Fort Morgan
REPRESENTATIVES: Carson Gallery, Denver; El Prado Galleries, Sedona, Arizona; Paint Horse Gallery, Breckenridge, Colorado

Robin J. Laws
b. 1946, United States

Another Gray Hare, 1989
Cottontail
Bronze
5 x 6 x 4

Collection of the artist

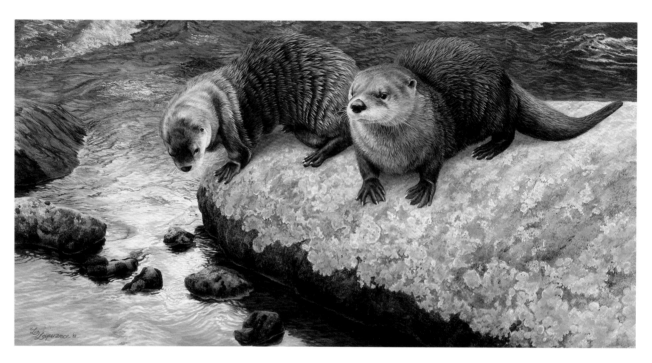

Liz Lesperance
b. 1954, Canada

Peaceful Pondering, 1988
River otter
Acrylic on board
14 x 26

Collection of George Hickson

"On a hiking trip in the Northwest Territories, the landscape was breathtaking as far as the eye could see. But on this day the constant rain and dense fog forced me to look at nature's beauty in the little things surrounding me. It was the rock – with its subtle colors and delicate tapestry-like patterns – that caught my attention. Very smooth and flat, it lay in the middle of a small, fast-flowing brook, the water bubbling around it reflecting silvery-gray skies. I could easily imagine a couple of clownish otters sliding on and off into the water and then idyllically resting on the rock while drying off."

RESIDES: Kitchener, Ontario, Canada
EDUCATION: Sheridan College, Oakville, Ontario
MAJOR FIELDS: Technical illustration
EXHIBITIONS: *Birds in Art*, 1988; *Elephants: The Deciding Decade*, 1989, Zoocheck Canada, Toronto; Greystone Gallery, 1989, Kitchener
AWARDS: Artist of the Year, 1988, Nottawasaga Valley Conservation Authority, Barrie, Ontario; Artist of the Year, 1989, Wye Marsh, Midland, Ontario
REPRESENTATIVES: Simon Art Limited, Toronto, Canada

Mary M. Linenberg

"In December 1987 I discovered quite by surprise that a pair of coyote lived in the wooded, rolling hills surrounding my home. Their howling could be heard throughout the valley, and I paid tribute to this pair as I painted *December Song*." Here Mary Linenberg altered her normal attention to background detail to emphasize a feeling of coldness, desolation and loneliness. "The bare background not only portrays winter's bleakness but also symbolizes the coyote's unpopularity. It is a loner, an outcast that has the independence and cunning to survive human destructiveness."

RESIDES: Warrens, Wisconsin

Mary M. Linenberg
b. 1953, United States

December Song, 1989
Coyote
Oil on canvas
16 x 12

Collection of the artist

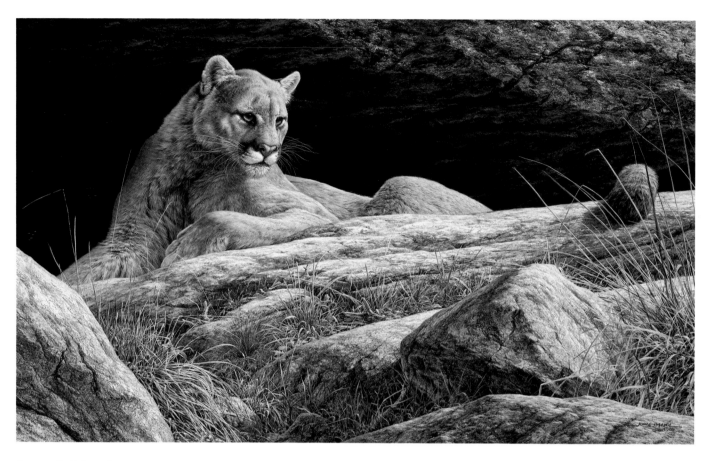

Jorge J. Mayol

b. 1948, Argentina

Cougar's Ledge, 1989
Acrylic on canvas
28 x 44½

Private collection

Jorge Mayol's wildlife subjects seem to spring to life on the canvas. Through a combination of careful observation and meticulous execution, he captures both the likeness of his animal subject and its spirit. "Cats have always interested me; I believe the cougar and jaguar are the most important hunters in all the Americas. I have studied the cougar extensively and painted the species many times." In *Cougar's Ledge*, Mayol has depicted this big cat as calm yet alert. While dangers or threats are not immediately present, the cougar remains poised for action, ready to respond to momentary changes in its environment.

RESIDES: Buenos Aires, Argentina
EXHIBITIONS: *Wildlife in Art*, 1987
REPRESENTATIVES: Mill Pond Press, Venice, Florida

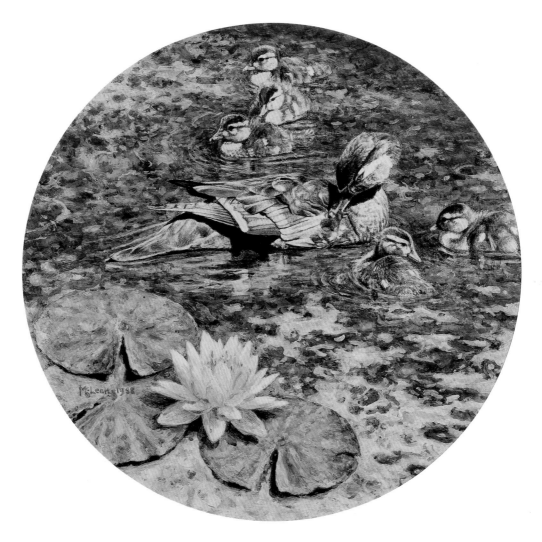

Wood Ducks was created for the fiftieth anniversary celebration of Ducks Unlimited Canada. George McLean responded to the challenge to work in a circular format so that the composition would be suitable as a plate. Though not problematic for McLean, the handling of the circular edge did require treatment different from the corners of a traditional painting. In this work he labored to temper any sentimentality. The lily pads and flower as well as the baby ducks were introduced for accuracy. McLean's dictum is this: "Everything in a picture is part of the design; if it doesn't belong, don't put it in."

RESIDES: Bognor, Ontario, Canada
EXHIBITIONS: *Birds in Art,* 1987-88
COLLECTIONS: Gallery of Sporting Art, Genesee Country Museum, Mumford, New York; Glenbow-Alberta Institute, Calgary; Royal Ontario Museum, Toronto; Seagrams, New York City
COMMISSIONS: Ducks Unlimited Canada; Leigh Yawkey Woodson Art Museum

George McLean
b. 1939, Canada

Wood Ducks, 1988
Casein watercolor on board
13 (diameter)

Private collection

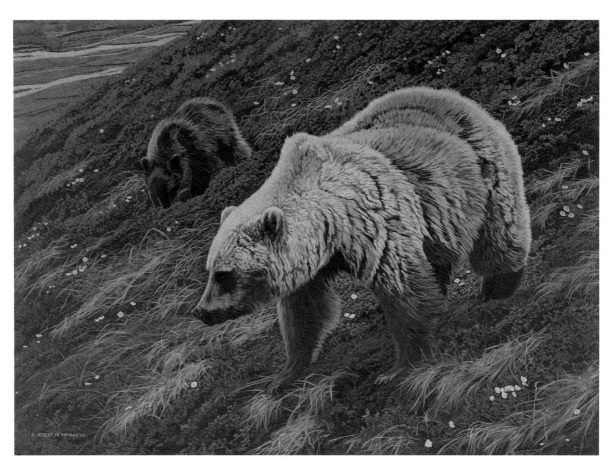

Robert J. McNamara
b. 1951, United States

A Slant Toward Summer, 1989
Grizzly bear
Acrylic on board
24 x 32

Collection of the artist

In *A Slant Toward Summer*, Robert McNamara chose to portray the grizzly sow and cub in a common scene, but he used the diagonal posture and slopes to stress the underlying tension and potential energy. "The sow is full of imminent motion. In the next second she might explode into action, charging down the slope in the direction of the slanted blades of grass." McNamara prefers to prominently feature the animal so he may fully develop its characteristics and anatomical details, such as the fur. "Depicting the sow's eye was a struggle because I wanted a correct and balanced expression of intensity and mystery. I had to avoid overemphasizing the eye while presenting just the right degree of subtle highlights."

RESIDES: Cleveland, New York
EDUCATION: Syracuse University, Syracuse, New York
MAJOR FIELDS: Landscape architecture
EXHIBITIONS: *Adirondack Life*, 1988, Lake Placid Center for the Arts, Lake Placid, New York; Burnet Park Zoo, 1988, Syracuse; *Northeastern Wildlife Exposition*, 1988, New York State Museum, Albany; *On My Own Time*, 1988-89, Everson Museum of Art, Syracuse; *New York Wildlife Art*, 1988-89, New York State Fair, Syracuse; *Birds in Art*, 1989; Beaver Lake Nature Center, 1989, Baldwinsville, New York
REPRESENTATIVES: Frameworks and Wildlife Art Gallery, Barneveld, New York

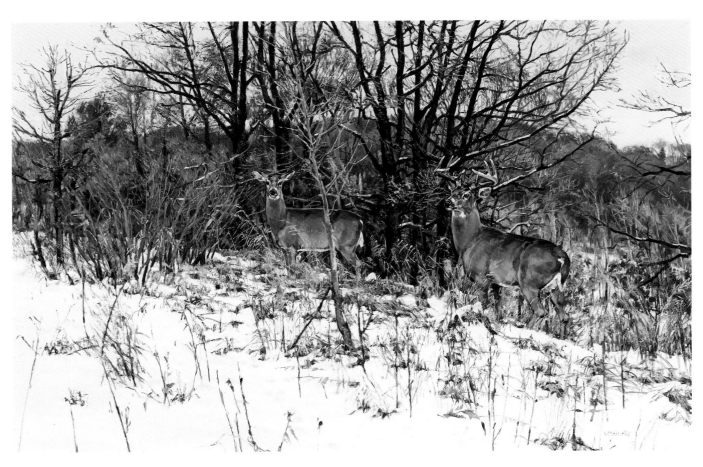

Concern with landscape is of primary importance for Wayne Meineke. Working in the style of the *plein-air* impressionist painters, his observation of the outdoors enables him to accurately reflect nature's natural colors, atmosphere and light. "After many cold days spent painting, I set up my easel to resume work on the landscape for *Whitetail Ridge*. But this day had a special surprise for me. As I gazed at the scene looking for appropriate details, I realized that a buck had walked through since the day before and scraped the bark off my little foreground sapling – a perfect finishing touch."

RESIDES: Edina, Minnesota
EXHIBITIONS: *Arts for the Parks*, 1988, National Park Academy of the Arts, Jackson, Wyoming; *Wild Wings Fall Festival*, 1988, Lake City, Minnesota; *Wildlife Art*, 1989, Minnesota Wildlife Heritage Foundation, Minneapolis
BIBLIOGRAPHY: "In the Field: Wayne Meineke," *Wildlife Art News*, September/October 1988
REPRESENTATIVES: W. Meineke Studios, Edina, Minnesota

Wayne Meineke
b. 1949, United States

Whitetail Ridge, 1989
White-tailed deer
Oil on linen
26 x 40

Collection of the artist

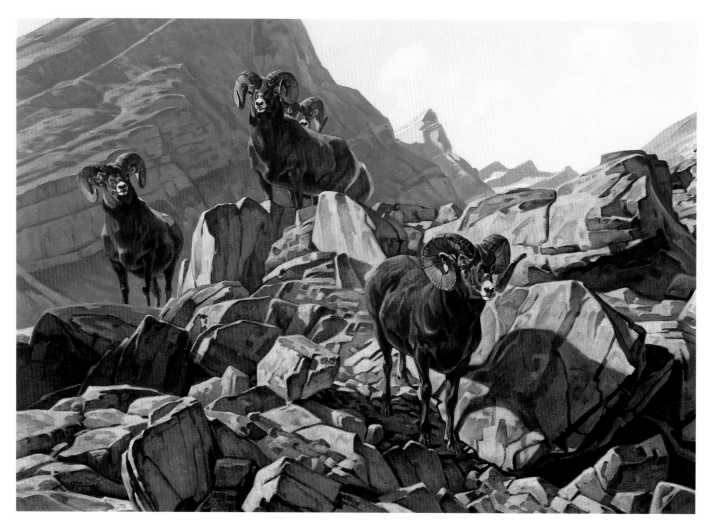

Dan Metz
b. 1951, United States

On the Slide, 1989
Rocky Mountain bighorn sheep
Oil on canvas
24 x 32

Collection of the artist

Hiking through the Canadian Rockies was for Dan Metz the prelude to creating *On the Slide*. "My challenge was to translate five glorious weeks in the high country and the exhilaration of bighorn rams into a powerful painting. I wanted to give the viewer the sensation of breathing pure alpine mountain air." *On the Slide* is typical of Metz's current work – North American big game animals shown at their best in fall or early winter.

RESIDES: Delano, Minnesota
EXHIBITIONS: *Wildlife Art*, 1988, Minnesota Wildlife Heritage Foundation, Minneapolis; *Miniatures '89*, White Oak Gallery, Edina, Minnesota
BIBLIOGRAPHY: "Art & Etc.," *Sporting Classics*, March/April 1989
REPRESENTATIVES: Grasslands Gallery, Edmonton, Alberta, Canada; Wild Wings, Lake City, Minnesota

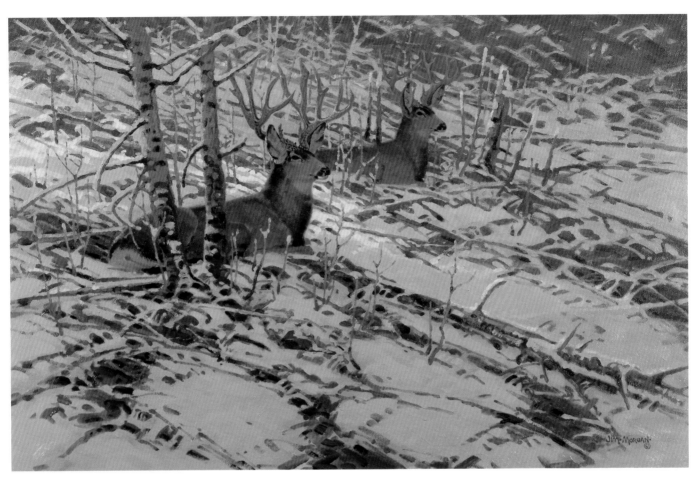

While James Morgan emphasizes the background in his work, he seeks to achieve a balance between the subject and its environment. This harmony is further aided by the play of light and shadow and subtle color changes. Sunlight filtering through a small aspen grove harboring two abandoned deer beds in the snow was actually the starting point for *Resting Mule Deer*. Later it evolved into a study of edges and contrasts. "Utilizing form and color – not detail – I tried to capture the feeling of the animals and their surroundings."

RESIDES: Mendon, Utah
EDUCATION: Utah State University, Logan
MAJOR FIELDS: Art
EXHIBITIONS: *Birds in Art*, 1987-89; *Arts for the Parks*, 1988, National Park Academy of the Arts, Jackson, Wyoming; *Society of Animal Artists*, 1988, Cumming Nature Center of the Rochester Museum and Science Center, Naples, New York; *Waterfowl Festival*, 1988, Easton, Maryland; *Western Rendezvous of Art*, 1989, Holter Museum of Art, Helena, Montana; *Birds of America*, 1989, Francesca Anderson Gallery, Boston
COLLECTIONS: Crescent Cardboard Company, Chicago; Leigh Yawkey Woodson Art Museum; Puakea Bay Ranch, Honolulu
REPRESENTATIVES: Hole in the Wall Gallery, Ennis, Montana; O'Brien's Art Emporium, Scottsdale, Arizona; Wild Wings, Lake City, Minnesota

James Morgan
b. 1947, United States

Resting Mule Deer, 1989
Oil on linen
20 x 30

Collection of Joe DeSaye

W. Rock Newcomb

b. 1945, United States

Tortoise Twilight, 1989
California desert tortoise
Scratchboard
9 x 18

Collection of the artist

After traveling the desert roads of California and Nevada for twenty-four years, Rock Newcomb saw his first wild tortoise in August 1989. He was not prepared for the reality of this encounter: "The physical make-up of the desert tortoise is remarkably complex while at the same time intricately beautiful. My goal was to enable the viewer to see this species in detail, close-up." Scratchboard is uniquely suited for this purpose, although achieving the high contrast and textural surfaces evident in *Tortoise Twilight* requires a painstakingly meticulous technique. Newcomb spent hundreds of hours "pecking" his tortoise into existence.

RESIDES: Fullerton, California
EDUCATION: California State University, Fullerton
MAJOR FIELDS: Art
EXHIBITIONS: *Birds in Art,* 1988; *Pacific Rim Wildlife Art Show,* 1989, Tacoma, Washington; *The Real Thing,* 1989, Brea Civic and Cultural Center, Brea, California
COLLECTIONS: West One Bank, Boise, Idaho; *Idaho Outdoor Digest,* Rupert
BIBLIOGRAPHY: "Newcomb Considered," *Idaho Outdoor Digest,* June 1988; "Two Idaho Artists Featured in International Art Exhibit," *Idaho Outdoor Digest,* December 1988; "Fullerton High Teacher Features Scratchboard Art at Sports Show," *Fullerton Daily Star-Progress,* January 5, 1989; "Fullerton Artist, Teacher Starts His Work From Scratch," *The Orange County Register,* January 11, 1989
REPRESENTATIVES: Sadell's Gallery, Covina, California; Sport'en Art, Sullivan, Illinois

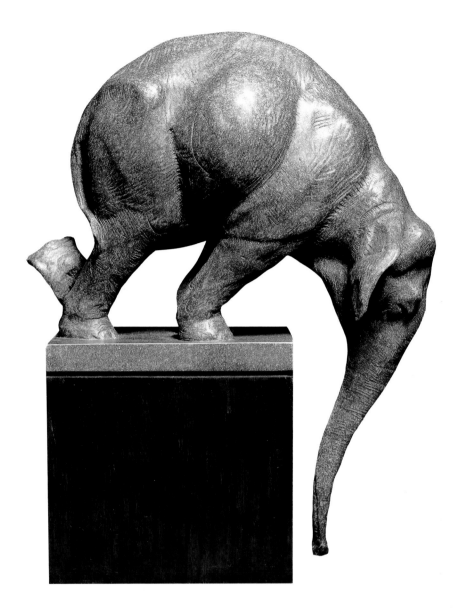

"At the Denver Zoo, I saw an Indian elephant futilely trying to reach melted snow in a normally-dry outdoor winter trough. The elephant's questing posture projected its inherent strength as well as its balance and grace." Because Dan Ostermiller drew on research from an animal in captivity, not in its natural habitat, he utilized the geometric shape of the base to suggest a manmade environment.

RESIDES: Loveland, Colorado
EXHIBITIONS: Fenn Galleries, 1988, Santa Fe, New Mexico; *Society of Animal Artists*, 1989, Boston Museum of Science
AWARDS: Award of Merit, 1988, *National Art Exhibition of Alaska Wildlife*, Anchorage Audubon Society, Anchorage; First Place Sculpture, 1989, *Texas Cowboy Artists Association*, El Paso
COLLECTIONS: Wyoming State Capitol, Cheyenne; Fleisher Art Museum, Scottsdale, Arizona
COMMISSIONS: Du Pont Corporation, Wilmington, Delaware; City of Estes Park, Colorado; Horseshoe Bay Yacht Club, Horseshoe Bay, Texas
BIBLIOGRAPHY: "Bronze: The Rock of Ages II," *Wildlife Art News*, March/April 1988
REPRESENTATIVES: Fenn Galleries, Santa Fe, New Mexico; Nedro Matteucci Fine Art, Santa Fe, New Mexico

Dan Ostermiller
b. 1956, United States

High and Dry, 1989
Indian elephant
Bronze
13 x 10 x 5

Collection of the artist

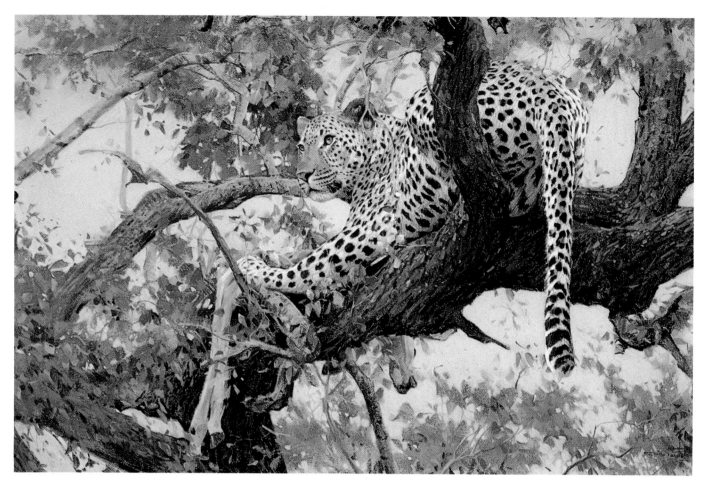

Dino Paravano
b. 1935, Italy

Leopard With Impala Kill, 1989
Pastel on paper
28 x 42

Collection of the artist

The combination of the leopard's beauty and its struggle for survival was a challenge faced and met by Dino Paravano in *Leopard With Impala Kill*. The viewer can sense the drama here: The sleek, agile cat has climbed higher and higher with its kill, goaded by the presence of a lioness below. Paravano's mastery of pastel enables him to use the medium to its utmost advantage to portray the softness and subtle coloration of the leopard's fur as well as the animal's natural tree-top domain.

RESIDES: River Club, South Africa
EDUCATION: Johannesburg Art School
EXHIBITIONS: *Wildlife in Art*, 1987; *Birds in Art*, 1987-89; *Society of Animal Artists*, 1988, Cumming Nature Center of the Rochester Museum and Science Center, Naples, New York, and 1989, Boston Museum of Science; *The Finest in Wildlife Art*, 1989, Trailside Galleries, Jackson, Wyoming; *The Kill*, 1989, Everard Read Gallery, Johannesburg
COLLECTIONS: Kruger National Park; Leigh Yawkey Woodson Art Museum
COMMISSIONS: National Parks Board, Pretoria; South Africa Nature Conservation Centre, Johannesburg
PUBLICATIONS: *Last Horizons*, St. Martin's Press, 1989 (illustrator)
REPRESENTATIVES: Sportsman's Edge/King Gallery, New York City; Mill Pond Press, Venice, Florida; Trailside Galleries, Scottsdale, Arizona

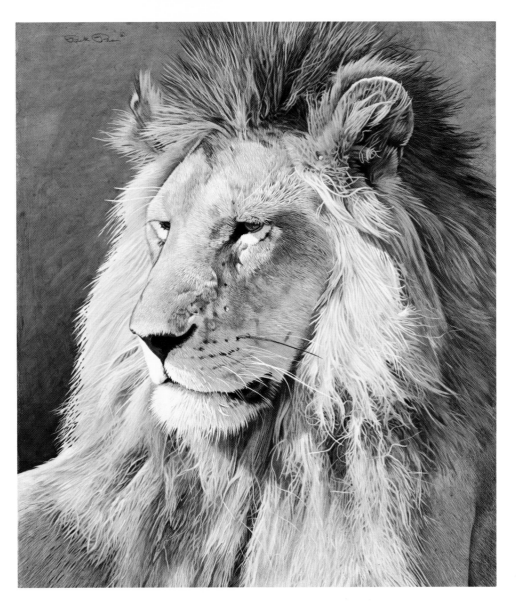

Mara Lion is a study in textures and shadows. Rick Pas chose to focus on the lion's head and shoulders, eliminating all background elements to emphasize the animal's most textural features. While Pas has often used only small portions of a subject abstractly, here he treats the lion more like a traditional portrait. "I concentrated on the short, smooth hair on the face, the matted, tangled mane, and the strong light and shadows. I wanted to convey the personality of this individual animal."

RESIDES: Burton, Michigan
EDUCATION: Eastern Michigan University, Ypsilanti
MAJOR FIELDS: Art
EXHIBITIONS: *Birds in Art*, 1987
COLLECTIONS: Michigan Bell, Detroit
COMMISSIONS: Potter Park Zoological Society, Lansing, Michigan; Charles Stewart Mott Foundation, Flint, Michigan
BIBLIOGRAPHY: "A Dark, Dark Day Indeed," *Audubon*, July 1988

Rick Pas
b. 1958, United States

Mara Lion, 1989
Acrylic on board
20 x 16

Collection of
Robert W. Stocker, II

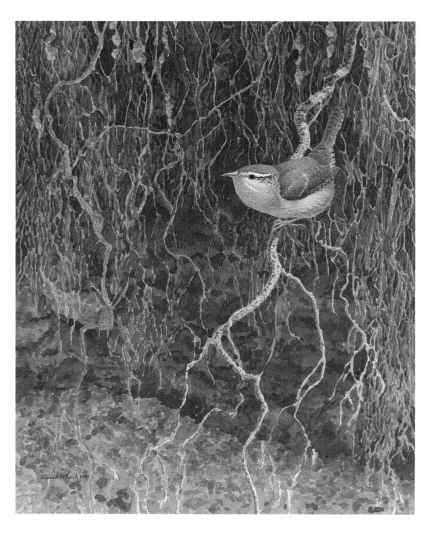

David Plank

b. 1934, United States

Carolina Wren, 1989
Watercolor on handmade paper
15 x 12

Collection of the artist

While bird behavior and the species' environmental requirements are important to David Plank, artistic considerations dominate when he decides what to paint. "The warm colors and design possibilities attracted me to this setting where Carolina wrens search for insects among the rootlets hanging from a cutbank along a stream." Watercolor is Plank's preferred medium because it suits his temperament. He is able to achieve subtle blending of colors and striking textural distinctions between the bird and its surroundings.

RESIDES: Salem, Missouri
EXHIBITIONS: *A Celebration of Wildlife,* 1988, Missouri Botanical Garden, St. Louis; *Birds in Art,* 1989
COLLECTIONS: Missouri State Historical Society, Columbia
PUBLICATIONS: Covers, *Bird Watcher's Digest,* March/April 1988, March/April 1989

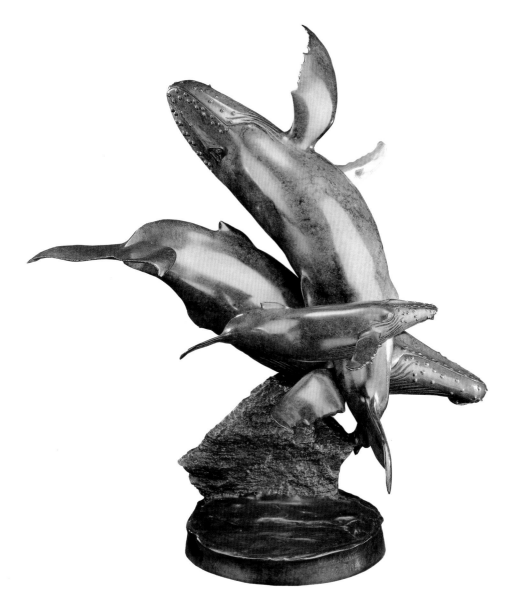

In *Rhapsody and Blue*, Randy Puckett depicts the grace and majesty of humpback whales. They live in a three-dimensional environment, moving like birds. This freeform motion in a sculptural presentation allows for the fluid interplay of mass, line and space. Although Puckett has dived to within fifteen feet of humpback whales, he cites the lack of accurate observation of cetaceans as an obstacle in portraying the species. Despite the advances in underwater photography, even the best is distorted to some degree by the necessity of using a wide angle lens.

RESIDES: Salinas, California
EDUCATION: University of Wisconsin, Stevens Point
MAJOR FIELDS: Political science
EXHIBITIONS: *Mystic International*, 1988, Mystic Seaport Museum and Maritime Gallery, Mystic, Connecticut; Dolphin Gallery, 1990, Lahaina, Hawaii; *Kauai Art '90 Celebration of the Sea*, Kahn Gallery, Kapaa, Hawaii
AWARDS: John Stoneman Marine Environmental Award, 1988, Ocean Research Foundation, Toronto
COLLECTIONS: Cetus Corporation, Oakland, California; Deep Ocean Engineering, Oakland; Mako Films Limited, Toronto; Oregon State Marine Sciences Center, Newport
COMMISSIONS: Monterey Bay Aquarium, Monterey, California

Randy Puckett
b. 1946, United States

Rhapsody and Blue, 1988
Humpback whale
Bronze
19½ x 17 x 14

Collection of the artist

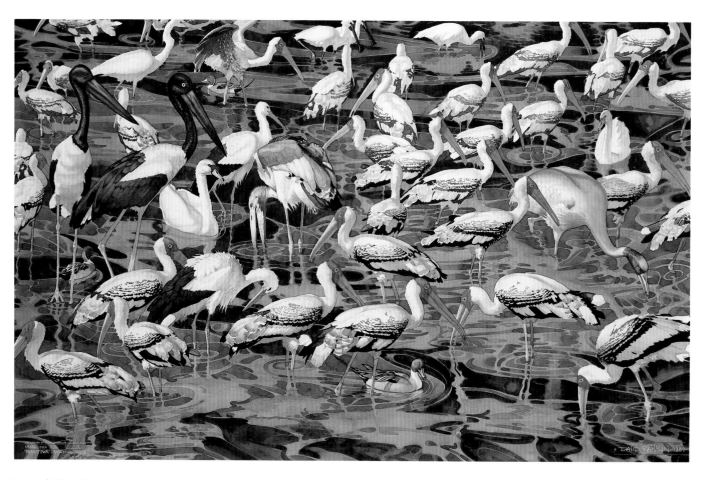

David Rankin
b. 1945, United States

Morning in Bharatpur, 1989
Watercolor on rag board
38 x 58

Collection of the artist

David Rankin began studying, sketching and photographing the astonishing variety of rural India's birds in 1970 while at a classic yoga hermitage in the Himalayan foothills. "Growing up in the Midwest, I knew the indigenous birds; but India, with more than twice the number of birds in the United States and Canada combined, overwhelmed me." The diverse groups of feeding storks, cranes, herons and other birds depicted in *Morning in Bharatpur* lend themselves to "natural abstraction," Rankin's term for the complex and intriguing designs found so readily in nature. The patterns created by dozens of multicolored birds thrashing about in water presented a tremendous challenge to Rankin. "Controlling the various values, light source and basic design elements is difficult, but achieving an abstract effect using recognizable realistic elements and accurately depicted species and habitats is a real joy."

RESIDES: University Heights, Ohio
EDUCATION: Cleveland Institute of Art
MAJOR FIELDS: Illustration, graphics and portrait painting
EXHIBITIONS: Art Gallery for Collectors, 1988, Willoughby, Ohio; Scheele Galleries, 1989, Cleveland Heights, Ohio; *Birds of India*, 1989, Scheele Galleries
COLLECTIONS: Creative Flavors, Chagrin Falls, Ohio; Board of Education, Toledo, Ohio; Toledo Museum of Art
COMMISSIONS: Holden Arboretum, Kirtland Hills, Ohio; International Crane Foundation, Baraboo, Wisconsin; Shaker Lakes Regional Nature Center, Shaker Heights, Ohio
BIBLIOGRAPHY: "Artist in India," *Minolta Mirror Magazine*, 1989; "The Fabulous Birds of India," *Taj Magazine*, January 1990
REPRESENTATIVES: Scheele Galleries, Cleveland Heights, Ohio

"I wanted to show how pheasants have changed their habits. They used to hold tight in any cover until you nearly stepped on them. Now, as *Weedy Draw* shows, they take off far ahead of you or run for the deepest cover. They will also use trees for protection when they fly if there is no other escape." In order to illustrate this change in the pheasants' behavior, it was necessary that Maynard Reece establish the proper background. Indeed, the trees, weeds and rolling landscape are as important in conveying the mood of the painting as the birds themselves.

RESIDES: Des Moines, Iowa
EXHIBITIONS: *Wildlife in Art*, 1987; *Birds in Art*, 1987-89; *Outdoor Writers Association of America*, 1989, Des Moines
AWARDS: Washington Duck Stamp, 1989; Master Wildlife Artist, 1989, *Birds in Art*
COLLECTIONS: Leigh Yawkey Woodson Art Museum; Murco Drilling Corporation, Shreveport, Louisiana; United Telecommunications, Kansas City, Missouri
COMMISSIONS: National Fish and Wildlife Foundation, Washington, D.C.
BIBLIOGRAPHY: "The Treasured Art of Maynard Reece," *Iowa Natural Heritage*, Spring 1989; "Look Closely, It Is All on the Canvas," *Living Bird Quarterly*, Winter 1989; "The Master's Class," *Birder's World*, December 1989
REPRESENTATIVES: Mill Pond Press, Venice, Florida

Maynard Reece
b. 1920, United States

Weedy Draw, 1988
Ring-necked pheasant
Oil on canvas
24 x 36

Private collection

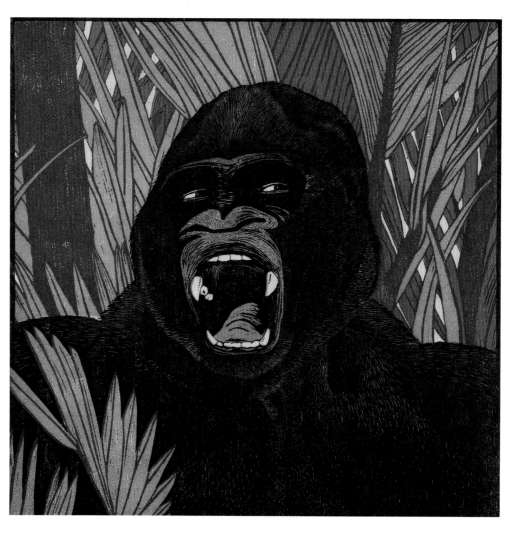

Andrea Rich
b. 1954, United States

Growling Gorilla, 1988
Mountain gorilla
Woodcut on Goyer paper
12½ x 12¼

Collection of the artist

Andrea Rich is intrigued with both the process of carving a woodblock and the actual printing, while challenged to stretch the medium to achieve her desired effect. "*Growling Gorilla* was inspired by a particular animal I encountered in a Florida zoo. His massive size and inherent strength impressed me; even resting he radiated power and his growling was indeed awesome. I wanted to capture his expression as he roared. The gorilla was not threatening directly – note the sideways glance – just releasing energy and making sure I was aware of him. To complete the composition, I filled the background with dense foliage reminiscent of the gorilla's home range, the relief pattern setting off the animal's dark bulk."

RESIDES: Santa Cruz, California
EDUCATION: University of Wisconsin, Whitewater
MAJOR FIELDS: Art education, printmaking
EXHIBITIONS: *Pacific Rim Wildlife Art Show*, 1988-89, Tacoma, Washington; *Birds in Art*, 1989; *Botanical and Wildlife Art*, 1989, Los Angeles Zoo; *In Search of the American Experience*, 1989, Museum of the National Arts Foundation, New York City; Clatsop Community College, 1989, Astoria, Oregon; Grants Pass Museum of Art, 1989, Grants Pass, Oregon
COLLECTIONS: Art Museum of Santa Cruz County, Santa Cruz; The Fine Arts Museums of San Francisco; Los Angeles Zoo
BIBLIOGRAPHY: "Woodblock Animals That Aren't the Cuddly Kind," *Grants Pass Daily Courier*, November 16, 1989
REPRESENTATIVES: Chicago Center for the Print, Chicago

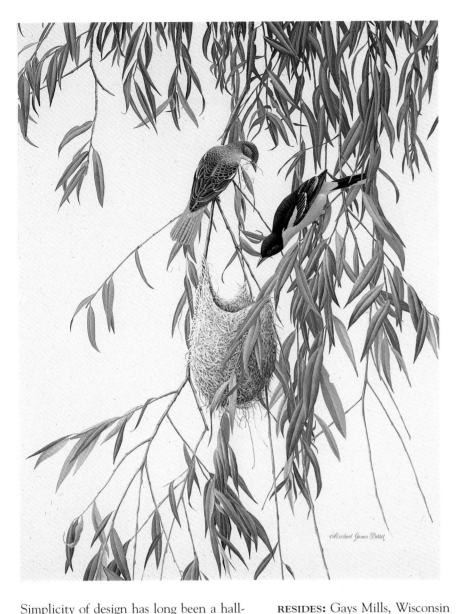

Simplicity of design has long been a hall-mark of Michael Riddet's work. Whether a vignette such as *Orioles' Retreat* or a more expansive work with a fully inte-grated background, the clarity and preci-sion of the primary subject are the artist's goals. Pure enjoyment is Riddet's desired effect here, and the bright colors of the familiar songbird work toward this actualization.

RESIDES: Gays Mills, Wisconsin
EDUCATION: Roosevelt University, Chicago
MAJOR FIELDS: Biology
EXHIBITIONS: *Birds in Art,* 1987
COLLECTIONS: Leigh Yawkey Woodson Art Museum; National Wildlife Federation, Vienna, Virginia; Northern Trust Company, Chicago
COMMISSIONS: Franklin Mint, Franklin Center, Pennsylvania; Rugby Laboratories, New York City
PUBLICATIONS: Cover, *Wisconsin Natural Resources,* December 1989; *Birds of Winter,* Simon and Schuster, 1990 (illustrator)
REPRESENTATIVES: Hawkshead Limited Wildlife Art, Boscobel, Wisconsin

Michael James Riddet
b. 1947, England

Orioles' Retreat, 1989
Northern oriole
Acrylic on board
28 x 21

Collection of the artist

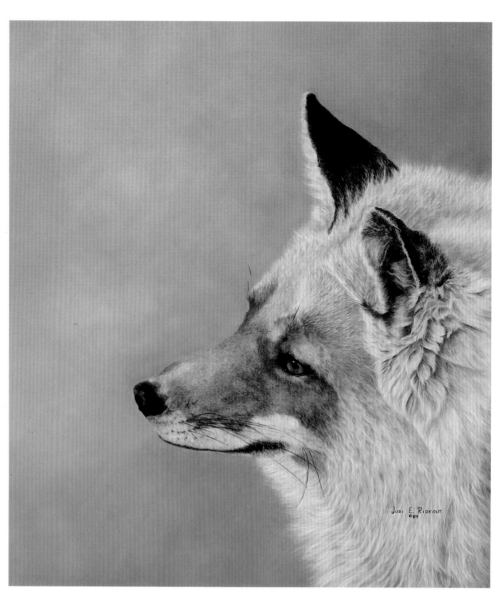

Judi E. Rideout
b. 1945, United States

Intent, 1989
Red fox
Pastel on paper
22 x 16½

Collection of Mary Middleton

Judi Rideout specializes in animal portraits. Backgrounds are unimportant to her; it is the meticulous detail of the primary subject that commands her full attention. Rideout uses pastels as a painting – rather than drawing – medium. In combination with a velour paper, which provides a textural surface, she is able to achieve remarkable likenesses. *Intent* demonstrates Rideout's ability to capture the softness of the fox's fur as well as the keenness in its eyes. Here the fox becomes a symbol: "With our environment changing so much, the fox is one animal found across most of the United States. It is a survivor!"

RESIDES: Palmer, Alaska
EXHIBITIONS: *National Art Exhibition of Alaska Wildlife*, 1988-89, Anchorage Audubon Society, Anchorage; *Pacific Rim Wildlife Art Show*, 1988-89, Tacoma, Washington
COLLECTIONS: Alaska Pacific University, Anchorage; Matanuska Valley Federal Credit Union, Palmer
REPRESENTATIVES: Ride Out Studio, Palmer, Alaska

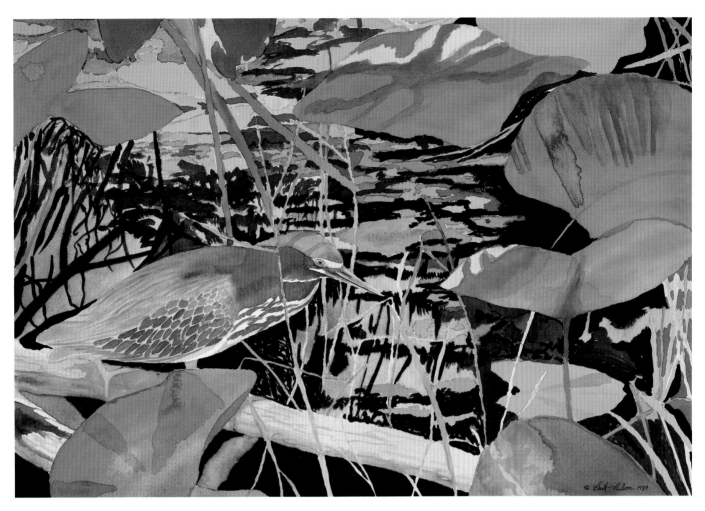

To capture the intense concentration of the green heron just before it dipped into the water to catch a minnow, Bart Rulon stressed its eye and head area. "Watching this bird was a treasured experience. I was only a few feet from it and in awe to be that close without the aid of a blind. Although I could only watch, the images were lasting." Transparent watercolor represents a new direction for Rulon; previously he executed more detailed acrylic and oil paintings. These different mediums enable him to utilize both an expressive and a controlled style for variety in his work.

RESIDES: Lexington, Kentucky
EDUCATION: University of Kentucky, Lexington
MAJOR FIELDS: Scientific illustration
EXHIBITIONS: *Guild of Natural Science Illustrators National*, 1989, Santa Barbara Museum of Natural History, Santa Barbara, California; *Pacific Rim Wildlife Art Show*, 1989, Tacoma, Washington; *Art and Wildlife in Kentucky*, 1989, Kentucky Department of Fish and Wildlife Resources, Lexington
COLLECTIONS: University of Kentucky Art Museum, Lexington
PUBLICATIONS: *Zoology Laboratory Manual*, Kendall/Hunt Publishing Company, 1988, 1989, 1990 (illustrator); Cover, *Current Ornithology*, Plenum Publishing Corporation, 1990

Bart Rulon
b. 1968, United States

Hunting in the Everglades, 1989
Green heron
Watercolor on Arches paper
22 x 30

Collection of the artist

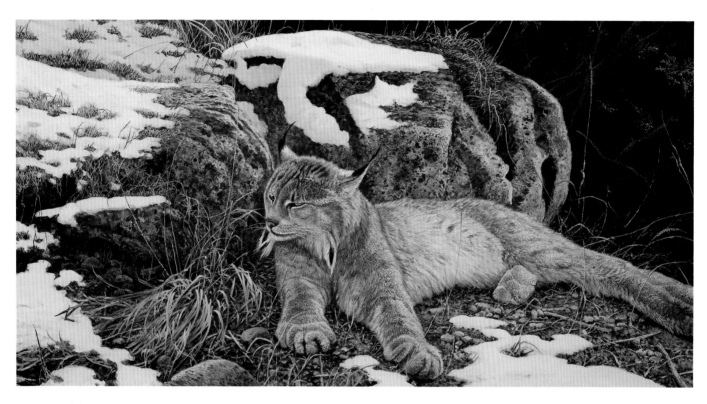

Alan Sakhavarz

b. 1945, Iran

Time to Rest, 1989
Lynx
Casein watercolor on board
24 x 42

Private collection

"In nature I am attracted most to the contrast between texture and form. *Time to Rest* explores the disparity between the cat's soft winter coat and the rough background rocks. I have also captured a moment of rest and tranquility, a brief interlude when the lynx is free from the ongoing struggle for survival." To this end, Alan Sakhavarz wants to heighten the viewer's appreciation for the gradually vanishing world of nature.

RESIDES: Mississauga, Ontario, Canada
EDUCATION: Tehran University, Tehran, Iran
MAJOR FIELDS: English literature
EXHIBITIONS: Beckett Gallery, 1988, Hamilton, Ontario; *Birds in Art*, 1988-89
COLLECTIONS: McLeod Young and Weir Limited, Toronto; *Ontario Out of Doors*, Toronto; Canadian Wildlife Federation, Ottawa
COMMISSIONS: Guelph University, Guelph, Ontario; Mutual Life Canada Company, Toronto
REPRESENTATIVES: Burdette Wildlife Gallery, Orton, Ontario, Canada

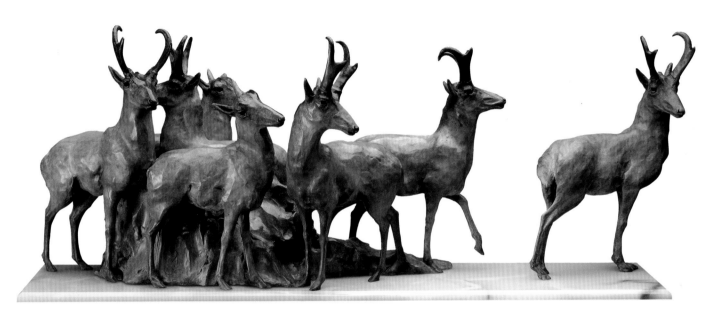

Antelope at Ingomar stems from a study trip made by Sherry Sander to Ingomar, Montana. She finds that incorporating multiple animals into her designs presents challenges. "With one animal, only one head and four legs need to be considered, but in a piece such as *Antelope at Ingomar,* there are seven heads and twenty-eight legs with which to contend. Because I want each animal to project its own presence and sense of movement within the overall composition, a single missing element can destroy the balance of the entire work."

RESIDES: Kalispell, Montana
EDUCATION: University of Oregon, Eugene
MAJOR FIELDS: Art
EXHIBITIONS: *National Academy of Western Art,* 1988-89, National Cowboy Hall of Fame and Western Heritage Center, Oklahoma City; *Birds in Art,* 1989; *Society of Animal Artists,* 1989, Boston Museum of Science; *Step Into the Wild,* 1990, The High Desert Museum, Bend, Oregon
AWARDS: Award for Sculpture, 1989, *Allied Artists of America,* American Academy and Institute of Arts and Letters, New York City
COLLECTIONS: Leigh Yawkey Woodson Art Museum; Wildlife of the American West Art Museum, Jackson, Wyoming
BIBLIOGRAPHY: "Every Piece a New Concept," *Focus/Sante Fe,* April/May 1989
REPRESENTATIVES: GWS Galleries, Carmel, California

Sherry Sander
b. 1941, United States

Antelope at Ingomar, 1989
Bronze
14 x 36 x 11

Collection of the artist

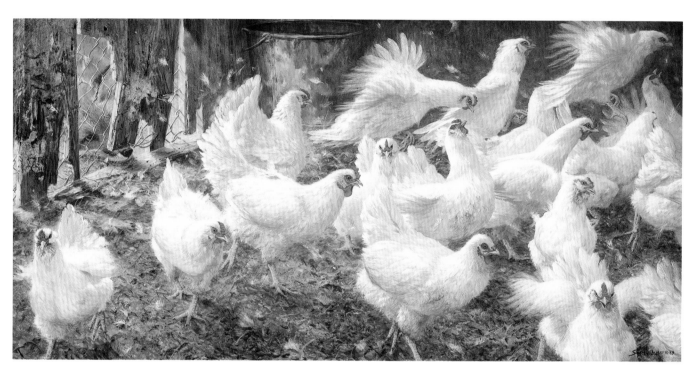

John Seerey-Lester
b. 1945, England

Sneak Peek, 1989
Red fox and
white Plymouth rock
Acrylic on board
24 x 48

Collection of the artist

To create *Sneak Peek*, John Seerey-Lester chose to work from an idea rather than from an observed event. "The idea for this painting stemmed from a design concept, not an actual happening, although I suspect this is a common enough occurrence. My goal was to depict a sense of dramatic movement that began at the painting's left edge and fanned out to the right. The use of white chickens against a dark background enabled me to emphasize the sudden fluttering of wings and scurrying of birds caused by a red fox so obscure that viewers may not immediately notice it even though the fowl are aware of its presence." It was important to Seerey-Lester that the predator be unable to actually reach its quarry.

RESIDES: Nokomis, Florida
EDUCATION: Salford Technical College, Lancashire, England
MAJOR FIELDS: Graphic design, painting
EXHIBITIONS: *Wildlife in Art*, 1987; *Birds in Art*, 1987-89; *Miniatures '88 and '89*, White Oak Gallery, Edina, Minnesota; *Small Works of Art*, 1989, Altermann and Morris Galleries, Houston and Dallas; *Farewell to the Eighties*, 1989, Corpus Christi Gallery, Corpus Christi, Texas
AWARDS: New York Duck Stamp, 1990
COLLECTIONS: Society for Wildlife Art of the Nations, Sandhurst, England
COMMISSIONS: National Fish and Wildlife Foundation, Washington, D.C.
BIBLIOGRAPHY: "Captured on Canvas," *Gulf Coast*, June 1989; "John Seerey-Lester: A Constant Adventure," *U.S. ART*, March 1990
REPRESENTATIVES: Lindart, Sarasota, Florida; Mill Pond Press, Venice, Florida

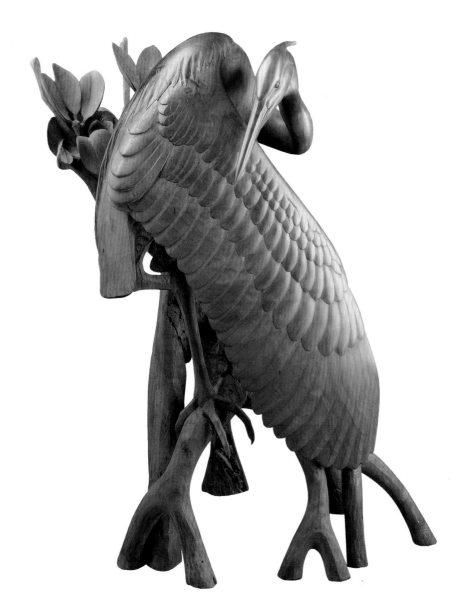

"*Preening Heron* was inspired by the mangrove swamps of the Gulf and the animation of a heron as it grooms itself."

RESIDES: Kent, Ohio
EXHIBITIONS: *Wildlife in Art*, 1987; *Birds in Art*, 1987-89; *World Championship Wildfowl Carving Competition*, 1988-89, Ocean City, Maryland; *Birds in Art: An Ohio Perspective*, 1989, Cincinnati Museum of Natural History; *Expressions of a Quiet Nature*, 1989, Grand Central Art Galleries, New York City
AWARDS: First Place, World Class, Interpretive, 1988, *World Championship Wildfowl Carving Competition*
COLLECTIONS: Cleveland Museum of Natural History; Leigh Yawkey Woodson Art Museum; Society for Wildlife Art of the Nations, Sandhurst, England; The Ward Museum of Wildfowl Art, Salisbury, Maryland
REPRESENTATIVES: Grand Central Art Galleries, New York City

John T. Sharp
b. 1943, United States

Preening Heron, 1988
Great blue heron
Cherry
48 x 22 x 20

Collection of the artist

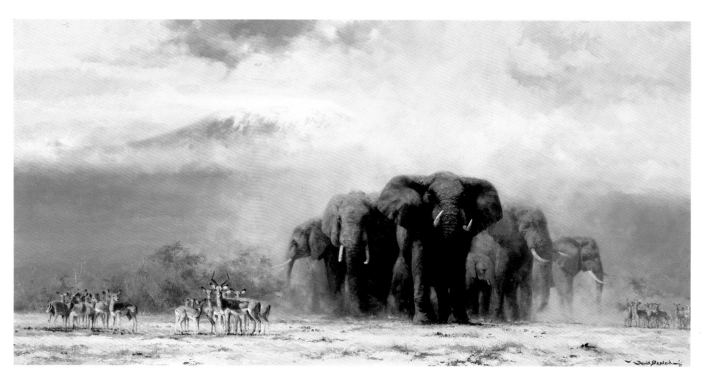

David Shepherd

b. 1931, England

Amboseli, 1989
African elephant and impala
Oil on canvas
22 x 44

Collection of
Mr. and Mrs. Walter Scott, Jr.

David Shepherd has long championed conservation of the environment and wildlife of Africa. His efforts are supported by the David Shepherd Conservation Foundation. He uses his artwork to benefit the Foundation; *Amboseli* was auctioned at a Foundation event shortly after its completion in early 1989. Mount Kilimanjaro, while one of Africa's most beautiful sites, is a very fragile environment. Here Shepherd first saw elephants in the wild. Although elephants are now virtually his "trademark," when combined with impalas, he still struggled to achieve the correct proportion of one species to the other.

RESIDES: Godalming, Surrey, England
EXHIBITIONS: *Wildlife in Art*, 1987; *Wildlife Artists of the World*, 1988, The Tryon Gallery, London
AWARDS: Master Wildlife Artist, 1987, *Wildlife in Art*
COLLECTIONS: Gallery of Sporting Art, Genesee Country Museum, Mumford, New York; Glenbow-Alberta Institute, Calgary, Alberta, Canada; Leigh Yawkey Woodson Art Museum
PUBLICATIONS: "Protecting Them All: David Shepherd," *U.S. ART*, March 1990
BIBLIOGRAPHY: "David Shepherd: The Dramatic Landscape," *Wildlife Art News*, September/October 1987
REPRESENTATIVES: The Greenwich Workshop, Trumbull, Connecticut

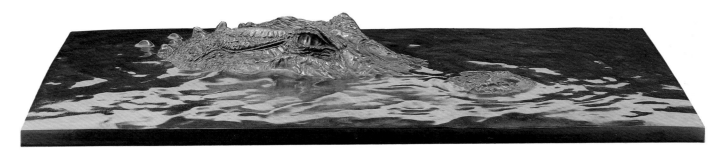

Donald Sible does not attempt to tell a complete story in his bronzes. Instead he labors to reveal his subject's inner strength, to convey a sense of life and movement. "I want to prime the viewer's imagination. The sensation I strive to create is one of being in the same environment as the species depicted. In *Methuselah*, this occurs when the viewer's eyes and the alligator's eyes are level." Sible's work spans a variety of subjects from birds of prey to aquatic life, and most is cast in bronze. "I find bronze to be an extremely rewarding medium. When molten, it can capture minute detail. When solidified, bronze is strong enough to allow for complex compositions unattainable in other mediums."

RESIDES: San Gabriel, California
EDUCATION: California State University, Long Beach; Humboldt State University, Arcata, California
MAJOR FIELDS: Art
EXHIBITIONS: *Botanical and Wildlife Art*, 1988, Los Angeles Zoo
AWARDS: Elliot Liskin Memorial Award, Sculpture, 1989, *Society of Animal Artists*, Boston Museum of Science

Donald Sible
b. 1946, United States

Methuselah, 1988
Alligator
Bronze
6½ x 34½ x 27½

Collection of the artist

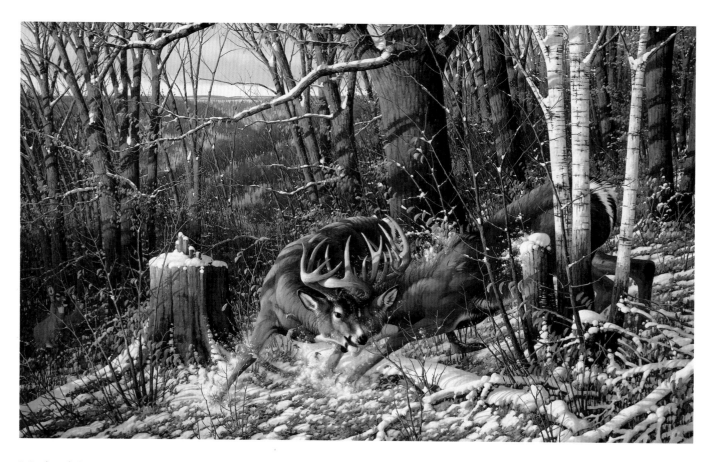

Michael Sieve

b. 1951, United States

Oak Ridge Battle, 1988
White-tailed deer
Oil on canvas
30 x 48

Collection of the artist

Michael Sieve finds his greatest inspiration to be experiences in the field, although *Oak Ridge Battle* depicts a scene that occurred only several hundred yards from his home. The two clashing bucks were familiar to Sieve; he had observed them frequently. The challenge was, therefore, to capture the power, action and drama of the fight. "This proved to be very difficult; I started and stopped twice before this third attempt came together. The anatomy of fighting deer is hard to see and to research. I had to rely on memory, horn models and dozens of sketches to achieve what I was after."

RESIDES: Houston, Minnesota
EDUCATION: Southwest Minnesota State College, Marshall
MAJOR FIELDS: Studio art
EXHIBITIONS: *Wildlife in Art*, 1987; *Birds in Art*, 1988; *Wildlife Art*, 1988-89, Minnesota Wildlife Heritage Foundation, Minneapolis; *Wild Wings Fall Festival*, 1988-89, Lake City, Minnesota
AWARDS: Best of Show, 1988, *Wildlife Art*; Idaho Upland Bird Stamp, 1988
COLLECTIONS: Leigh Yawkey Woodson Art Museum; Pope and Young Club, Placerville, California; State of Oregon, Portland
BIBLIOGRAPHY: "Michael Sieve, The Complexity of Nature," *Birder's World*, January/February 1988; "Michael Sieve, A Pictorial Essay," *Midwest Art*, January/February 1988; "Meet Bowhunting Artist Mike Sieve," *Bowhunter*, October 1989
REPRESENTATIVES: Wild Wings, Lake City, Minnesota

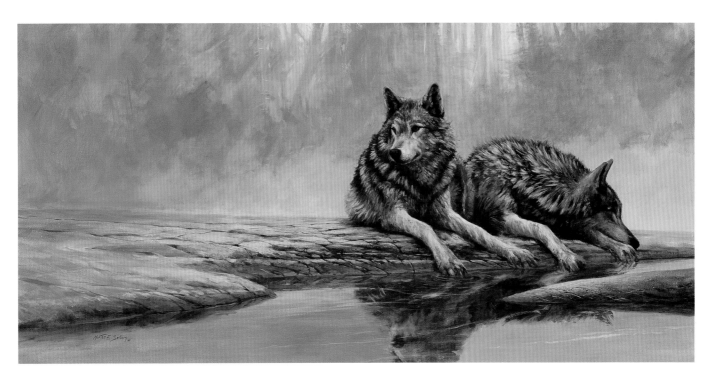

Morten Solberg's painting is a combination of an impressionistic background and a realistic wildlife subject. "I paint in both directions – loose and tight – simultaneously." Solberg's intent here is to draw attention to the possibility of reintroducing the wolf to Yellowstone National Park. "The wolf is one of the more intelligent and family-oriented wild species. For *Reflection*, I wanted to present this animal as passive but alert."

RESIDES: Sebastopol, California
EDUCATION: Cleveland Institute of Art
EXHIBITIONS: *Wildlife in Art*, 1987; *Birds in Art*, 1987-89; *American Watercolor Society*, 1988, New York City; *Society of Animal Artists*, 1988, Cumming Nature Center of the Rochester Museum and Science Center, Naples, New York, and 1989, Boston Museum of Science; Christopher Queen Galleries, 1989, Duncans Mills, California; *Miniatures '89*, White Oak Gallery, Edina, Minnesota; Nicolaysen Art Museum, 1989, Casper, Wyoming; Conacher Gallery of Art, 1989, San Francisco
AWARDS: Award of Merit, 1988, *Society of Animal Artists*
COLLECTIONS: Cleveland Museum of Art; Leigh Yawkey Woodson Art Museum; National Academy of Design, New York City; The White House, Washington, D.C.
REPRESENTATIVES: Mill Pond Press, Venice, Florida

Morten E. Solberg
b. 1935, United States

Reflection, 1989
Timber wolf
Acrylic on canvas
24 x 48

Collection of the artist

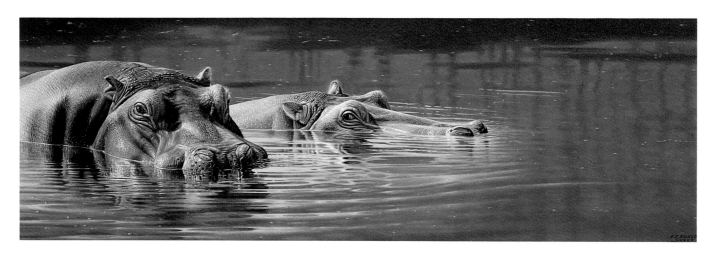

Francis E. Sweet
b. 1938, United States

River Horses, 1989
Hippopotamus
Oil on canvas
17 x 50

Collection of the artist

The massiveness of the hippopotamus coupled with the unique qualities of the animal's hide presented Francis Sweet with an exceptional contrast of form and texture. In addition, the composition of *River Horses* enabled a further comparison between the rough, wrinkled skin and smooth, reflective water. "I chose hippos because they are not painted as often as other African mammals. They are amusing and fearful as well as awesome and comical – quite a challenge for an artist."

RESIDES: Bowie, Maryland
EXHIBITIONS: *Waterfowl Festival*, 1988, Easton, Maryland; *Wildlife '88*, Upper Marlboro, Maryland; *Birds in Art*, 1988-89; *Ward Foundation Wildfowl Carving and Art Exhibition*, 1988-89, Salisbury, Maryland; *North American Wildlife Conference*, 1989, Wildlife Management Institute, Washington, D.C.; *Southern Maryland Wildlife*, 1989, Quail Unlimited, Laplata, Maryland
AWARDS: Maryland Duck Stamp, 1988; Logo Design Winner, 1989, Patuxent Research Institute, Laurel, Maryland; Idaho Duck Stamp, 1990
BIBLIOGRAPHY: "Duck Stamp Programs" and "Artists' Approach to the Challenge," *Wildlife Art, Journal of the Ward Foundation*, Fall 1988
REPRESENTATIVES: Francis E. Sweet Studios, Bowie, Maryland

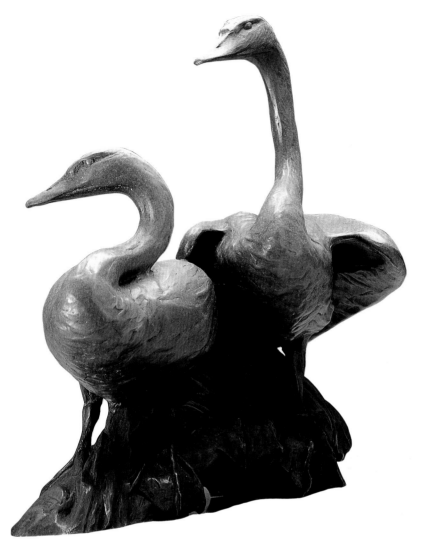

From initial concept to finished piece, *Partners in Time* required nearly a year to complete. Margery Torrey's design underwent several changes – from two rough torpedo shapes to the elegant pair in the third and final form. "Every winter the trumpeter swans flock to the Jackson Hole area. It is not unusual to see sixty to seventy swans paddling about on Platte Creek, just outside of town. In the cold air, mist rises from the creek, enveloping the swans. They become a stunning combination of white on white. I was drawn to the sculptural quality of the family groupings as the birds congregated on the grassy banks. *Partners in Time* depicts just such an occasion. The pen and cob are spending a quiet moment together after a morning spent feeding. The cob's wings are slightly raised in a stance both protective and defensive, warning off a swan that has intruded too closely on the pair."

RESIDES: Jackson, Wyoming
EDUCATION: Wellesley College, Wellesley, Massachusetts
MAJOR FIELDS: Art history
EXHIBITIONS: *Wildlife Art Show*, 1988, Bighorn Gallery, Jackson; *Birds in Art*, 1989; *Society of Animal Artists*, 1989, Boston Museum of Science
AWARDS: First Place Purchase Award, 1988, *Cowboy State Art Show*, Wyoming Pioneer Memorial Museum, Douglas; Curator's Choice Award, 1989, *Western Regional Art Show*, Cheyenne Frontier Days Old West Museum, Cheyenne, Wyoming
REPRESENTATIVES: Wildlife Images, Jackson, Wyoming

Margery Torrey
b. 1958, United States

Partners in Time, 1989
Trumpeter swan
Bronze
15¼ x 16¾ x 10

Collection of the artist

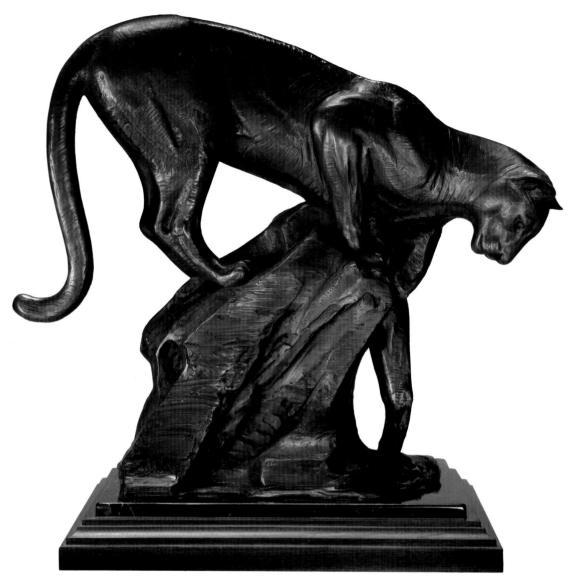

Kent Ullberg
b. 1945, Sweden

Cougar by the Stream II, 1988
Bronze
21 x 22½ x 12

Collection of the artist

Kent Ullberg's *Cougar by the Stream II* communicates the control, absolute elegance and contained power of cats. So that the viewer will perceive the beauty of nature through Ullberg's eyes, he imbues each work with an underlying design indicative of his love for nature. *Cougar by the Stream II* is composed of two opposing diagonal movements – through the rock and the cat's body – and the interplay of triangular negative shapes. Ullberg wants his sculpture to initiate a dialogue between artist and audience. He chooses to work in a representational style because it enables him to communicate on more levels than abstract or nonobjective art.

RESIDES: Corpus Christi, Texas
EDUCATION: Konstfack School of Art, Stockholm, Sweden
EXHIBITIONS: *Wildlife in Art*, 1987; *Birds in Art*, 1987-89; *D'Apres Nature*, 1989, Municipal Art Gallery, Luxembourg; Biologiska Museet, 1989, Stockholm; *The Naturalist Vision*, 1990, Art Museum of South Texas, Corpus Christi
AWARDS: Master Wildlife Artist, 1987, *Birds in Art*; Founder's Award, 1989, *National Sculpture Society*, New York City
COLLECTIONS: Gallery of Sporting Art, Genesee Country Museum, Mumford, New York; Leigh Yawkey Woodson Art Museum
BIBLIOGRAPHY: "Wildlife Sculpture as a Contemporary Expression," *U.S. ART*, March 1989
REPRESENTATIVES: Sportsman's Edge/King Gallery, New York City; Trailside Galleries, Scottsdale, Arizona

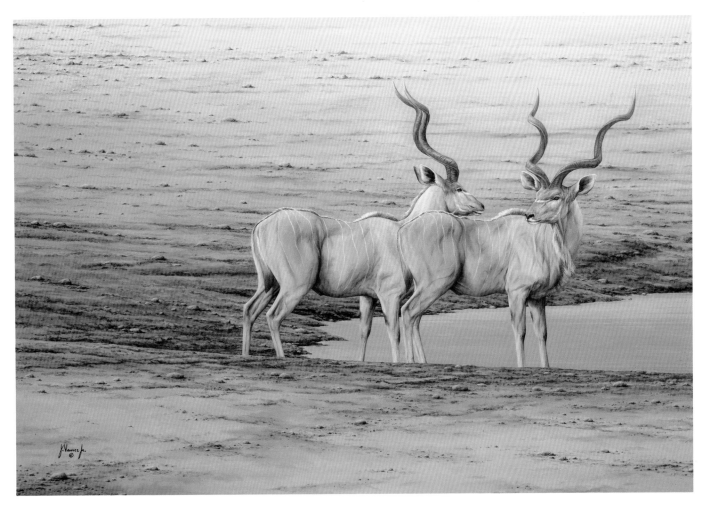

Several years ago Joseph Vance visited Etosha National Park in what is now Namibia, and this visit as well as other expeditions to Africa serve as stimuli for his paintings. "The incredible beauty of the area and its wildlife has stayed with me. Although it took time to finally get to this painting, the inspiration for *Etosha Kudus* was a single bull kudu that came down one afternoon to a waterhole near Fort Namutoni. It can be difficult to achieve the absolutely stark landscape around some of the African waterholes. The second kudu was added for interest and to enliven the composition. I tried to capture the graceful caution these animals exhibit when they are out in the open."

RESIDES: Brooklyn, New York
EDUCATION: Brooklyn College, Brooklyn
MAJOR FIELDS: Economics
EXHIBITIONS: *Society of Animal Artists*, 1988, Cumming Nature Center of the Rochester Museum and Science Center, Naples, New York, and 1989, Boston Museum of Science
COMMISSIONS: World Wildlife Fund, New York City
REPRESENTATIVES: Blue Heron Gallery, Wellfleet, Massachusetts

Joseph Vance, Jr.
b. 1943, United States

Etosha Kudus, 1989
Greater kudu
Acrylic on board
20½ x 30

Collection of the artist

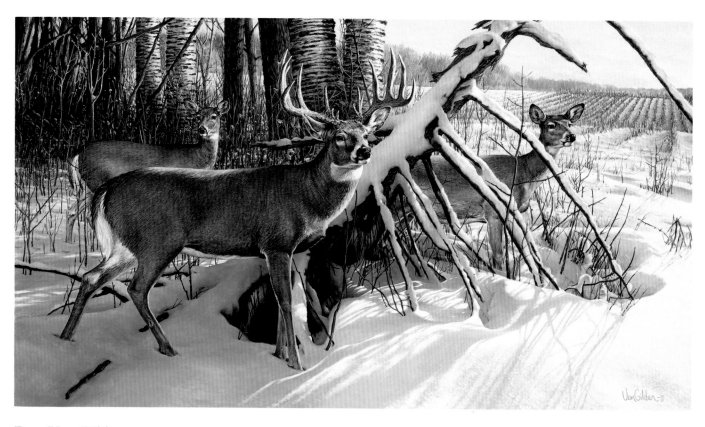

Ron Van Gilder
b. 1946, United States

Stepping Out, 1989
White-tailed deer
Oil on board
22½ x 36

Collection of the artist

Stepping Out is representative of the evolution Ron Van Gilder's work has undergone since he started painting wildlife. "I began with game birds and waterfowl since they were the easiest to research in the field. In the last six years my fieldwork has concentrated on big game from Alaska to Africa and that is what my work will, to a great extent, represent in the future." *Stepping Out* can perhaps be viewed as a study in contrasts: While the deer are alert and keenly aware of their surroundings, they are at the same time serene and at ease in their natural habitat.

RESIDES: Cedar, Minnesota
EDUCATION: Minneapolis College of Art and Design
MAJOR FIELDS: Graphic design
EXHIBITIONS: *Birds in Art*, 1988-89; *Wild Wings Fall Festival*, 1988-89, Lake City, Minnesota; *Wildlife Art*, 1988-89, Minnesota Wildlife Heritage Foundation, Minneapolis
AWARDS: Mississippi Flyway Artist of the Year, 1989, National Ducks Unlimited; Palette and Chisel Award, 1989, Minnesota Ducks Unlimited
COLLECTIONS: Leigh Yawkey Woodson Art Museum
COMMISSIONS: Minnesota Conservation Federation, Minneapolis; National Tree Farm Association, Washington, D.C.
BIBLIOGRAPHY: "Turning Oils Into Water," *Sporting Classics*, March/April 1988
REPRESENTATIVES: Wild Wings, Lake City, Minnesota

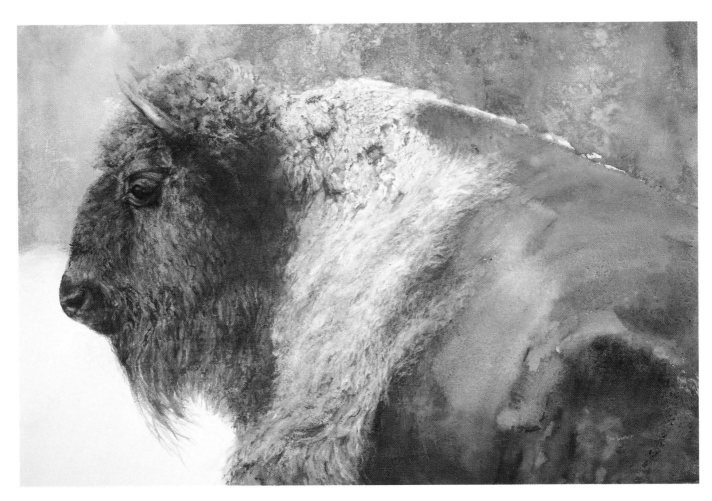

"As *Tatanga* evolved, I was so impressed by the beauty of the massive forms, I was almost afraid to push onward; a wrong stroke could break the spell and everything that was beautiful would suddenly dissolve." Sue Westin resolved that conflict to create a portrait of a bison with its back like a mountain and a portion of its fur resembling tall, wind-bowed grass before a pending storm. "*Tatanga* is a departure stylistically; it is looser, bolder and more massive. Initially my goal was an image that would evoke the sensation of a mountain scene. However, upon completion the feeling was spiritual. One could interpret this to mean the bison is symbolic of the American Indian or of our vanishing wilderness, but for me it touches on something not so easily explained."

RESIDES: Derby Line, Vermont
EDUCATION: Hartwick College, Oneonta, New York
MAJOR FIELDS: English
EXHIBITIONS: *Birds in Art*, 1987-89; *Society of Animal Artists*, 1988, Cumming Nature Center of the Rochester Museum and Science Center, Naples, New York, and 1989, Boston Museum of Science; *In a Natural Light*, 1989, Gallery on the Green, Woodstock, Vermont
COLLECTIONS: Community National Bank, Derby Line, Vermont
BIBLIOGRAPHY: "Artist Vignette: Sue Westin," *Wildlife Art News*, September/October 1989
REPRESENTATIVES: Barrow Marsh Gallery, Woodbury, Connecticut

Sue Westin
b. 1950, United States

Tatanga, 1989
American bison
Watercolor on gessoed paper
25 x 38½

Collection of the artist

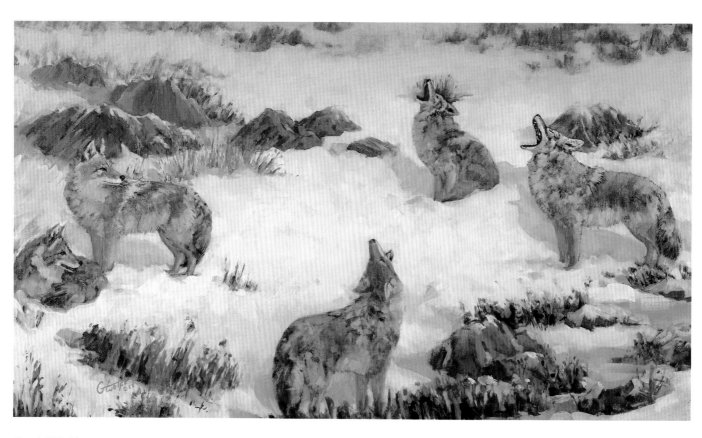

Gail Wolfe

b. 1935, United States

Serenade of the Coyotes, 1988
Oil on canvas
24 x 40

Collection of the artist

When Gail Wolfe first noticed a buck-wheat shrub with its range of sparkling colors from rusts and buffs to brilliant crimsons, she wanted to incorporate these startling colors as well as the shapes into her painting. Because wild canids are a favorite subject, she envisioned a composition with coyotes amid a field of partially snow-covered buckwheat. "When howling and surrounded by natural beauty, the coyote is a wonder to behold. I find the profile of the head the most balanced and truly elegant of all the canids. It is held in a different position, thrown back, yielding an arched neck and a most beautiful line with which to work."

RESIDES: Tujunga, California
EDUCATION: Art League of Los Angeles, Van Nuys, California
MAJOR FIELDS: Art
EXHIBITIONS: San Gabriel Fine Art Gallery, 1988, San Gabriel, California; *Society of Animal Artists*, 1989, Boston Museum of Science; *Animal Imagery*, 1989, St. Hubert's Giralda, Madison, New Jersey; *Wildlife '89*, San Bernardino County Museum, Redlands, California
COLLECTIONS: R and B Aircraft, North Hollywood, California; J and D Industries, Sunnyvale, California; Wolves and Related Canids, Agoura, California
PUBLICATIONS: "Artist Vignette: Gail Wolfe," *Wildlife Art News*, May/June 1989
REPRESENTATIVES: Art Tower Gallery, Cambria, California; Creel Creek Wildlife Gallery, Erieville, New York; Johnson Pasadena Galleries, Pasadena, California

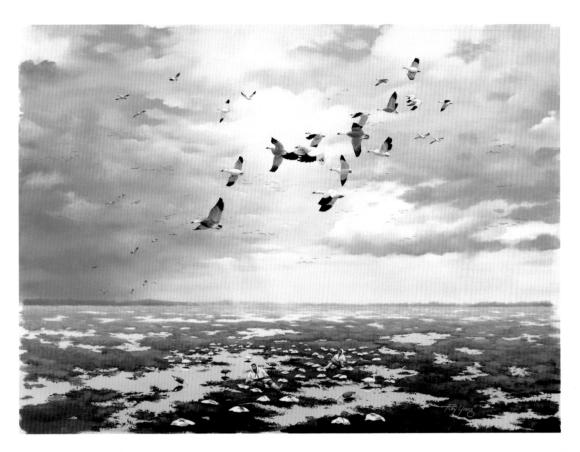

Ray Young's interest in painting wildlife is to capture the sportsman's interaction with game animals. *Snows and Blues* derives from a scene he observed on a goose hunt over flooded rice fields in southwestern Louisiana. "The sight and sound of tens of thousands of snow, blue and white-fronted geese rising from their roosts and moving to feeding grounds is one of the most awe-inspiring experiences of my life outdoors. I tried to convey their power and majesty by the use of great distance and heavy skies. *Snows and Blues* captures the tension and anticipation as the hunters try to lure the geese with calls and large decoy spreads, the adrenaline rush of calling in the geese, and the seemingly endless time it takes for them to drift into range."

RESIDES: Kennesaw, Georgia
EDUCATION: Memphis Academy of Arts, Memphis, Tennessee; Middle Tennessee State University, Murfreesboro
MAJOR FIELDS: Painting and drawing
EXHIBITIONS: *North Carolina Wildlife Federation Exhibition*, 1988-89, Raleigh, North Carolina
AWARDS: First Place, Oils, 1988, *North Carolina Wildlife Federation Exhibition*

Ray Young
b. 1958, United States

Snows and Blues, 1989
Oil on board
24 x 30

Collection of the artist

Production Notes

TYPOGRAPHY: Goudy Oldstyle, Goudy Oldstyle Italic and Goudy Oldstyle Bold

PAPER: Cover, 12 pt. Carolina Cover, coated one side; Fly Sheet, 70 lb. Speckletone Text, Cream; Text, 100 lb. Lithofect Plus Enamel Dull

PRINTING: Cover, four-color process, one PMS color and matte lamination; Text, four-color process, one PMS color and gloss varnish

PHOTOGRAPHY: Joe Coca, Fort Collins, Colorado: page 53; French Studios, Inc., Marion, Iowa: page 56; Larry Gau, Dayton, Minnesota: page 35: Impact Photography, Lexington, Kentucky: page 79; Tom Jones, Brunswick, Maine: page 28; K. D. Color, Cleveland, Ohio: page 74; Lorran Meares, Omaha, Nebraska: page 84; Mill Pond Press, Venice, Florida: pages 22, 26, 50, 62, 75, 82, 87; Ted Mock Photography, Palo Alto, California: page 27; Tad Motoyama, Los Angeles, California: page 85; Roy Murphy, Covina, California: page 68; Northwestern Photographics, Eugene, Oregon: page 17; Pribisco Photography, Ligonier, Pennsylvania: page 54; Riddell Ad Agency, Jackson, Wyoming: page 57; Mel Scherbarth, Milwaukee, Wisconsin: page 30; Maurice Sherman, New York City: page 24; Larry Sommer, Becker Communications, Schofield, Wisconsin: pages 16, 36, 38, 49, 58, 59, 61, 76, 83, 88, 94, 95; Robert Western, Pacific Grove, California: page 73; Dan White, Manistique, Michigan: page 47; Wild Wings, Lake City, Minnesota: page 92

Unless otherwise specified, photography courtesy of the artist.

CATALOGUE COMPILATION: Donna Sanders, Chippewa Falls, Wisconsin

DESIGN: Creative Services, Marathon Communications Group, Wausau, Wisconsin

COLOR SEPARATIONS: Lithographics, New Berlin, Wisconsin

PRINTING AND TYPOGRAPHY: Marathon Press Company, Marathon Communications Group, Wausau, Wisconsin

BINDING: Reindl Bindery, Milwaukee, Wisconsin

Printed in the United States of America

Leigh Yawkey Woodson Art Museum
Franklin and Twelfth Streets
Wausau, Wisconsin 54401 USA
Telephone: 715-845-7010
FAX: 715-845-7103